JACOB EPSTEIN

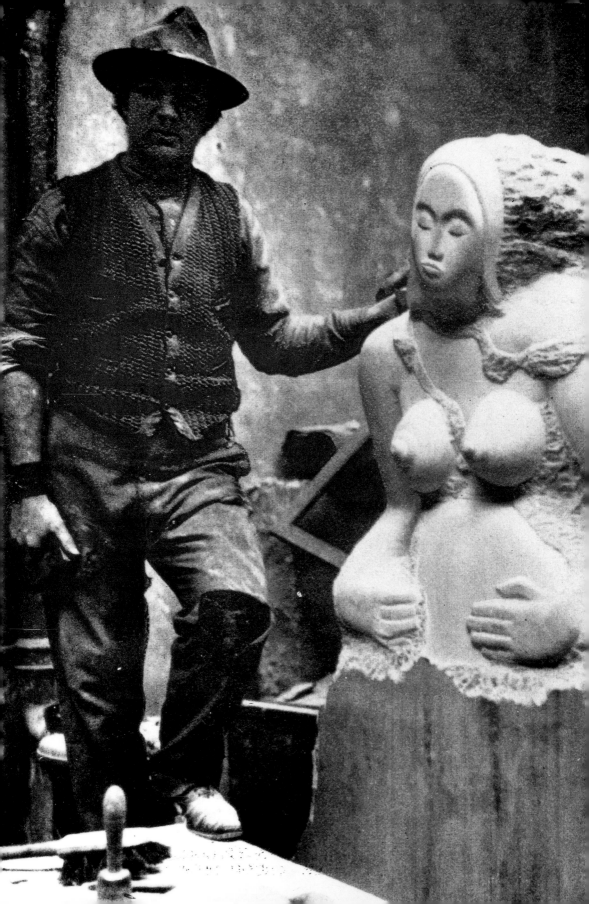

JACOB EPSTEIN

Richard Cork

British Artists

Princeton University Press

For my sister Alison,
with love

Front cover: *Torso in Metal from the 'Rock
Drill'* 1913–16 (fig.31)

Back cover: *Jacob and the Angel* 1940–1
(fig.49)

Frontispiece: Epstein in his studio carving
Maternity, 1910–12

Published by order of the Trustees
of the Tate Gallery by
Tate Gallery Publishing Ltd
Millbank, London SW1P 4RG

Published in North America by
Princeton University Press
41 William Street
Princeton NJ 08540

ISBN 0-691-02945-8
Library of Congress Catalog
Card Number: 99-61245

Cover design by Slatter-Anderson, London
Front cover photograph by Gill Selby

Book design by James Shurmer

Printed in Hong Kong by South Seas
International Press Ltd

Measurements are given in centimetres,
height before width, followed by inches in
brackets

CONTENTS

ACKNOWLEDGEMENTS

I first became involved with Epstein through *Rock Drill*. Researching a book about Vorticism, I began to realise just how remarkable this amalgam of man-made driller and ready-made machine really was. Lady Epstein was kind enough to talk to me about her husband's attitude to the successive stages of the sculpture. She showed me an important preparatory drawing, and gave permission to use the *Torso in Metal from the 'Rock Drill'* as the basis for a putative reconstruction of the original version. Organising an exhibition on *Vorticism and its Allies* at the Hayward Gallery in 1974, I was determined to display a replica of the white plaster figure mounted on a real drill from the pre-war period. But my aim would never have been fulfilled without a chance meeting with Ken Cook, whose enthusiasm for the project matched my own. His wife Ann Christopher proved equally willing to take on the challenge, and the Science Museum alerted me to the existence of the Holman Brothers' fascinating rock drill museum in Cornwall. We visited the collection, discovering to our delight that Holmans' were willing to lend us an appropriate drill. The Hayward Gallery funded the reconstruction, and Ann and Ken produced the *tour de force* that astonished so many visitors to the Vorticist exhibition. A lost landmark in the history of modern European sculpture was thereby recovered, and I learned an immense amount about *Rock Drill* from the experience.

Other people helped me to examine different aspects of Epstein's early work. Yve-Alain Bois drove me across Paris to Père Lachaise Cemetery, and guided me through the maze of funerary monuments to the *Tomb of Oscar Wilde*. Anthony d'Offay, who for several years kept the mesmeric *Sunflower* carving as a talisman in his study, was always willing to show me the Epstein drawings and sculpture he had acquired. Our fascination with that phase of his art culminated in the exhibition *Jacob Epstein: The Rock Drill Period* at Anthony's gallery, for which I wrote the catalogue essay.

In two chapters of my later book, *Art Beyond the Gallery in Early 20th-Century England*, I explored different aspects of Epstein's work: the mutilated statues in the Strand, and the carvings he produced for Charles Holden's Underground Railways Headquarters at Westminster. Charles Tarling made available a wealth of unpublished material in the Holden archive at the offices of Adams, Holden & Pearson. Angela Young and the Librarian at the British Medical Association were equally helpful, and Paul Vaughan shared his memories of interviewing both Epstein and Holden for his history of the Association. I was particularly grateful to Henry Moore, who talked to me at length in 1981 about the Underground Railways building and its sculpture. Even then, decades after the Strand carvings were

destroyed, he was still angrily unforgiving about the Royal Academy's refusal to defend Epstein and save his statues.

When the great Epstein retrospective was staged at Leeds and London in 1987, I was invited to write further about his work by the catalogue editors, Terry Friedman and Evelyn Silber. I am especially glad that they allowed me to devote an essay to Epstein's achievements as a carver throughout his career, and my work undoubtedly benefited from conversations with them both. Soon afterwards, I began writing on art and the First World War for my lectures as Slade Professor of Fine Art at Cambridge. Epstein's experiences during the 1914–18 period played a notable part in my text, just as they did in my subsequent book *A Bitter Truth: Avant-Garde Art and the Great War*. Thanks are due to everyone at Cambridge with whom I was able to discuss the subject.

I also found immense stimulus during my three years as the Henry Moore Senior Fellow at the Courtauld Institute in the early 1990s. Researching a book on twentieth-century British sculpture, and teaching courses on the same subject, I enjoyed testing my own ideas and responses with staff and students alike. In particular, my Courtauld years helped me to write the essay on 'Jacob Epstein et la sculpture anglaise au debut du siècle', commissioned by Daniel Abadie for *Un siècle de sculpture anglaise* at the Galerie Nationale du Jeu de Paume, Paris, in 1996.

Celia Clear and Dick Humphreys of the Tate Gallery must both be thanked for inviting me to write the present book, thereby providing the opportunity to draw together all the disparate strands of my work on Epstein over the past thirty years. Preparing it also prompted me to track down, in the storeroom of the Metropolitan Museum in New York, his major early *Sun God* carving. I am grateful to Bill Lieberman for allowing me to see this sadly little-known sculpture, at present impossible to view satisfactorily. I hope that one day it will be placed on permanent display in the city where Epstein grew up.

My final thanks go, as ever, to my wife Vena and my children Adam, Polly, Katy and Joe. Their love and encouragement helped me throughout, and Vena deserves a special tribute for driving us through a Welsh rainstorm and a baffling labyrinth of suburban roads to visit the *Christ in Majesty* at Llandaff Cathedral.

INTRODUCTION

Epstein's position as a pioneer of modern sculpture in Britain is secure enough. At the same time, however, he has been curiously undervalued since his death in 1959. Certain aspects of his long and productive career have received considerable attention, but in other respects the true nature of his overall achievement remains unclear. When the Jeu de Paume in Paris staged a major survey of modern British sculpture in 1996, Epstein occupied the opening space with his *Torso in Metal from the 'Rock Drill'*.[1] But he was granted no further exhibits in a survey that implicitly dismissed the significance of everything he went on to produce over the next forty years.

During his lifetime, by contrast, he was subjected to a relentless amount of unwelcome attention. Ever since the young Epstein was nicknamed '*ce sauvage Americain*' by his teacher at the Académie Julian,[2] he attracted a steadily mounting fusillade of ire. The hatred hurled at sculpture as respectful of tradition as the Strand statues may be hard to comprehend today. But the declaration of nakedness in figures intended for an outdoor location proved inflammatory at the beginning of the century, and Epstein's determination to defy the taboos imprisoning human sexuality ensured that he was soon regarded as an automatic target for prudish disapproval.

The hostility grew even more vicious and hysterical once his work departed from western precedent in order to explore alternatives drawn from an ardent scrutiny of Asian, African and Oceanic work. Epstein's openness to so many cultures beyond Greco-Roman boundaries would be of incalculable benefit to the subsequent vitality of British sculpture. But his most xenophobic enemies, envenomed by the realisation that he was an American-born Jew of Polish descent, accused him of polluting British art with heretical ideas.[3] The myth of Epstein the barbarian reached its zenith during the inter-war period, when the Strand statues were dismembered and many other works vandalised. This sustained onslaught coincided with the rise of intolerance in Germany and the Soviet Union, where dissenting artists were systematically victimised. Anti-Semitism flourished in England as well as elsewhere in Europe, and Epstein found himself denounced most ferociously by those commentators who sought to purge modern art of its supposed racial impurities.

In one sense, at least, the vilification he endured with such stoicism had a beneficial outcome. When Epstein died, Henry Moore emphasised in an obituary tribute that 'he took the brickbats, he took the insults, he faced the howls of derision ... and as far as sculpture in this century is concerned, he took them first'. Epstein's courage was exemplary, providing in itself a model well worth emulating by successive generations of artists. But Moore

rightly went on to point out that 'the sculptors who followed Epstein in this country would have been more insulted than they have been had the popular fury not partially spent itself on him, and had not the folly of that fury been revealed'.[4] Moore often experienced considerable derision himself, particularly from cartoonists who mocked his willingness to carve holes through his recumbent figures. So he was better placed than anyone to appreciate how much fiercer had been the opposition Epstein withstood.[5]

In other ways, however, Moore's retrospective assessment of his former mentor served only to hinder any comprehensive understanding of Epstein's achievement. As a young man, Moore had received immense encouragement, praise and patronage from the older sculptor. The influence exerted by Epstein's early carvings on Moore's development in the 1920s was profound, and has never been fully analysed. While conveying his gratitude for the older man's indispensable help during that formative period, though, Moore discounted in his otherwise generous essay the importance of Epstein's carvings. 'He was a modeller, rather than a carver', Moore claimed, before going on to make the astonishing assertion that Epstein's portraits were 'his greatest work'. Finally, after singling out the late *Madonna and Child* in Cavendish Square for special commendation, Moore disclosed the full extent of his preference by concluding that, 'of the sculptor's media, his was surely clay'.[6]

Epstein's facility and vigour as a modeller is self-evident, and several of his bronze heads can indeed be counted among his most outstanding work. Evelyn Silber was right to emphasise in 1986 that 'it is primarily as a portrait sculptor that Epstein was and is celebrated'.[7] But the present book has been written in the belief that his prodigious activity as an incessantly commissioned portraitist serves rather to obscure Epstein's real stature. He once lamented that 'I must sometimes turn to and earn a living like other persons, and not indulge too much in strange and unrealizable longings and desires'.[8] The sheer proliferation of his commissioned busts, many undertaken in order to finance his appetite as a collector of non-western art or stave off the ever-present spectre of bankruptcy, threatens to overwhelm anyone attempting to define Epstein's career with clarity.

The truth is that his most complex and profound work can be found, more often than not, in his carvings. His prowess as a modeller of full-length figures may have produced work as memorable as *Risen Christ*, the Cavendish Square *Madonna and Child*, and *Christ in Majesty*. But Epstein invariably reserved his most deeply meditated resources for the arduous, unassisted act of cutting direct into stone.[9] He experienced great difficulty in selling his carvings, and several of the most outstanding ended up displayed as titillating amusements in a Blackpool funfair. Ultimately, though, their humiliating fate in no sense detracts from the intensity Epstein devoted to making them. Whether looking out to sea from his isolated cottage on the Sussex coast, or immured in a shed among the winter mists of Epping Forest, he summoned all his redoubtable energies to ensure that *Sunflower*, the 'flenite' women and the final *Doves*, no less than the later *Elemental, Jacob and the Angel* or *Lazarus*, embody the most impassioned and gravely aspiring of his sculptural ambitions.

1

'A SCULPTOR IN REVOLT'

Even when his adopted country belatedly tried to embrace him, Epstein never lost his vantage as an outsider. He stayed at a remove from British culture throughout his life, and retained enthusiastic memories of the multi-racial vitality animating the city of his birth. Today, Hester Street and its neighbourhood in New York's Lower East Side are near a fashionable area dominated by smart, expensive art galleries. But when he was born there in 1880, they were packed with refugees from across the world. Despite the poverty and chronic overcrowding, the young Epstein relished growing up in a district he later described as 'the most densely populated of any city on earth'. His own parents had arrived in New York as persecuted Polish immigrants, seeking refuge from anti-semitic pogroms. So he had an instinctive fellow-feeling for the 'swarms of Russians, Poles, Italians, Greeks and Chinese' who 'lived as much in the streets as in the crowded tenements'.[1] He preferred to stay there when his family moved to a more respectable neighbourhood, and drew the Hester Street market with incessant vigour from a decrepit wooden building hired for the purpose.

New York was, at that stage, far less stimulating as a centre for art. Once Epstein had discovered that sculpture was his absorbing interest, he realised how few examples of classical, renaissance and modern work could be studied there in the original. George Grey Barnard, who taught him at an Arts League modelling class, was in Epstein's eyes 'the only American sculptor one could have any respect for'.[2] Barnard's emphasis on assuming personal responsibility for cutting directly into the stone block amounted to a moral imperative, and Epstein would inherit that concern when he began to engage with carving. But even though he particularly admired Barnard's 1894 carving *The Struggle of the Two Natures of Man*, it failed to excite him as much as Donatello or Michelangelo. He yearned for the opportunity to see their work at first hand, and eventually booked a voyage to France with his earnings as an illustrator for Hutchins Hapgood's book *The Spirit of the Ghetto*. These deft, sharply observant black chalk studies revealed the full extent of Epstein's fellow-feeling for the people of the Lower East Side. He was fired by a strong social commitment and numbered among his friends the east-side activist James Kirk Paulding, who introduced Epstein to Walt Whitman at the Community Guild. The boldness of Whitman's poetry and his sensual, libertarian stance would remain of central importance to Epstein throughout his life.[3]

His greatest ambitions, though, were centred ever more firmly on three-dimensional form, and a winter spent at Greenwood Lake with his close

friend Bernard Gussow reinforced his determination to become a sculptor. Until then, the rocks and lakes of Central Park had provided him with a stimulating escape from the enclosed, clamorous urban world he usually inhabited. But now, living in a lakeside cabin surrounded by the mountainous New Jersey countryside, he encountered an entirely new source of excitement. 'I spent a winter doing little but tramping through snow-clad forests, cutting firewood, cooking meals and reading', he recalled. 'To earn a little money we both helped to cut the ice on the lake. This was very hard but congenial work, as we were taken to the ice-fields by sledges drawn by a team of horses in the early morning over the hard-frozen lake, and returned in the evening on the sledges, when we saw wonderful snow views of mountain sides ablaze with sunset colours. It was a physical life full of exhilaration and interest.'[4] The significance of that visit can hardly be overestimated. The overwhelming sense of natural grandeur, no less than the fierce delight associated with the act of cutting into the ice, would inform Epstein's approach to carving until the very end of his career.

In Paris, however, where he arrived in October 1902, modelling and drawing Michelangelo casts dominated his work as a student. The instruction he received at the Ecole des Beaux Arts was academic, and a subsequent period at Julian's emphasised the primary importance of working in clay from a model. Adopting the stance of a Whitmanesque rebel, he found the constraints irksome. But there were compensations. At the Louvre, he admired 'early Greek work, Cyclades sculpture, the bust known as the Lady of Elche, and the limestone bust of Akhenaton'. He also

1 *Lunch in the Shop* or *The Sweatshop* 1900–2 Black chalk on paper 53 × 43 (17 × 20⅞) Garman Ryan Collection, Walsall Museum and Art Gallery

11

recalled seeing, at the Trocadero, 'a mass of primitive sculpture none too well assembled'.[5] Although the impact of non-western carvings would later exert a profound influence on his work, and cause him to become a discerning collector of African, Oceanic and Indian sculpture, Epstein was not yet prepared to jettison European sources of stimulus. He visited Rodin's studio, where the energetic inventiveness of the work on display convinced him that the Frenchman was 'a revivifying force'.[6] Surviving photographs of the 'heroic-sized'[7] group of sun-worshippers he commenced around then suggest that he was in no mood to escape from Rodin's example.[8] The modelling of their flowing forms, with arms outstretched in homage as 'primitive men greeting the sun',[9] was uncomfortably close to the French master.

Only in his choice of non-western models did Epstein show the first signs of independence from Rodinesque precedent. In 1904 he wrote to his Brooklyn friend and patron Edward W. Ordway about a Sikh youth and a boy from Martinique, both of whom were posing for his Sunrise sculpture. The Indian was 'quite slender and tall and finely formed and his brown colour gives him a very sculptural appearance ... I daresay there is not another model like him in all Paris'. As for the 'negro lad' from Martinique, 'he is quite a splendid fellow ... and is only a model when he cannot get other work'.[10] Epstein's pride in using such unconventional, defiantly non-academic figures is evident. He intended to use the Sikh youth again in a bronze of two entwined male figures inspired by Whitman's 'Calamus poems on brotherly love'.[11] A vigorous 1905 sketch for this sculpture is especially intriguing, for the naked figures seem to be locked in a wrestling embrace prophetic of the impassioned bodies he would carve, many years later, in *Jacob and the Angel* (fig.49).

But he was not at all certain of his abilities at this stage. The sun-worshippers and *Calamus* group were destroyed in a fit of dissatisfaction,

2 *We Two Boys Together Clinging*, for Whitman's *Calamus*, c.1902 Pen and ink and coloured wash on paper 23 × 35.8 (9 × 14) Private Collection

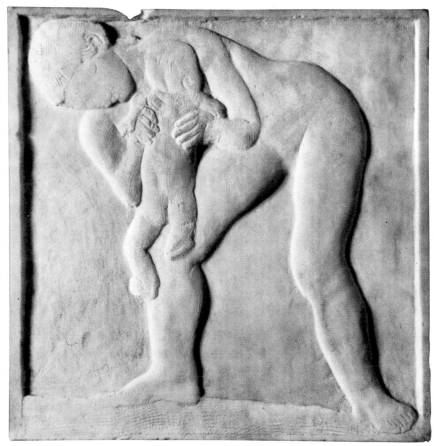

3 *Mother and Child*
1905–7
Marble relief
35.5 × 35.5
(14 × 14)
Birmingham
Museums and
Gallery

and the decision to settle in London did not immediately lead to a more fruitful period of work. Arriving there in January 1905, he soon befriended lively young artists who, like Augustus John, shared his energy and bohemian independence. His *Calamus* drawings, most notably a homoerotic pen and wash study inspired by Whitman's poem, *We Two Boys Together Clinging* (fig.2), impressed George Bernard Shaw, who described them to Robert Ross in March 1905 as 'amazing drawings of human creatures like withered trees embracing'.[12] But the most impressive of Epstein's early London works are small modelled heads, above all the strangely martial portrait of John's baby son Romilly whose hair has been transformed into a gleaming helmet.

As a carver, though, he was for the moment more hesitant. His marble relief of a *Mother and Child* is marred by technical shortcomings, and yet Epstein's determination to revivify a predictable theme is evident already (fig.3). Caught at an ungainly angle, the woman struggles to retain her grasp on the obstinately writhing infant. We are a long way, here, from the complacent repose of so many Victorian maternity carvings. And Epstein's commitment to carving direct in stone, a strategy he may have initially adopted at the urging of George Gray Barnard, gives this early relief an awkward vitality far removed from the polished, mechanically assisted blandness of Edwardian academic sculpture.

In view of this rawness, it may seem surprising that the twenty-seven year-old artist should now have received a major public commission. But Charles Holden, a young architect entrusted with designing the British Medical Association's new London headquarters, wanted a sculptor who shared his appetite for renewal. On the advice of the painter Francis Dodd, Holden visited Epstein's studio and was excited by 'a delicate and sensitive figure of a young girl holding in her hand a dove – it was in black wax, lifesize or slightly over, and was approaching completion'.[13] The pencil drawing that survives for this lost sculpture stresses the gawky vulnerability of nakedness (fig.4). Holden sensed that its maker could provide him with a memorable series of carvings for the facade of his building, soon to be erected on a prominent corner site in the Strand.

The two men discovered that they shared an enthusiasm for Whitman's poetry. Holden's passionate belief in the importance of introducing a revolutionary 'aboriginal force'[14] to British architecture chimed with Epstein's increasing desire to bring about a similar change in British sculpture. Although the lower, granite half of the BMA facade paid homage to C.R. Cockerell's previous building on the site, the upper half in Portland stone was more modernist in conception. Epstein's eighteen statues would play a vital role in the structure, for Holden intended that 'the series of white sculptural figures, on each side of the windows and set in a framework of dark granite, would serve to weave the two materials together like white stitching joining a dark to a light material'.[15]

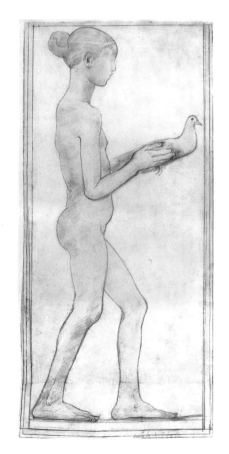

4 *Study for Girl with a Dove*, 1906–7 Pencil on paper 48 × 21 (19 × 8¼) Garman Ryan Collection, Walsall Museum and Art Gallery

Above all, though, Holden wanted his building to be enhanced by a sculptor who shared his conviction that 'we are ashamed of our nakedness – and yet it is in the frank confession of our nakedness that our regeneration lies'.[16] Epstein set to work at once, impatiently dismissing the BMA's proposal that he depict 'their historically famous medical men'.[17] Although he acceded to their demand for figures symbolising Medicine, Health and Chemical Research, the principal thrust of his scheme was powered by a determination to create, as he announced in 1908, 'noble and heroic forms to express in sculpture the great primal facts of man and woman'.[18] Classical, Renaissance and Rodinesque precedents lie behind the figures he produced, as well as the influence of Wiener Werkstätte statues by the Austrian sculptor Richard Lüksch reproduced in a 1906 issue of *The Studio*.[19] Epstein's debt to Greek sculpture in *Hygieia*, no less than his reliance on Michelangelo and Rodin in *Youth*,[20] is openly proclaimed.

Alongside these eclectic references to the past, however, a desire to celebrate the dignity of the naked human body unites the BMA sequence. The

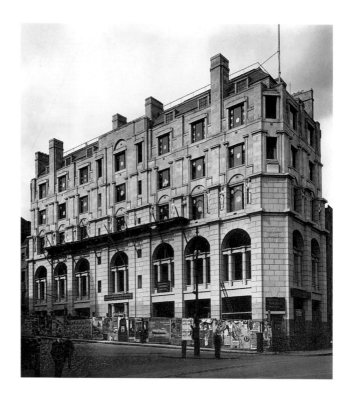

uncompromising realism of the old woman's head in *New-Born* (fig.6) suggests a debt to Donatello, but the contrast between her haggard stoicism and the baby she clasps like a votive offering is a quintessential reflection of Epstein's own outlook. So is the intimate rapport between mother and child in *Maternity*, the finest carving in the scheme (fig.7). An ink and pencil study for the woman's figure alone, stressing the ripeness of her swollen belly, is voluptuous enough to suggest that Epstein was already looking beyond Europe and finding, in Indian sculpture, a touchstone for his own pursuit of sensuality untrammelled by puritanical shame.

Maternity, however, proved to be Epstein's downfall. Its completion in the early summer of 1908 was immediately and hysterically deplored by the National Vigilance Association, whose headquarters happened to be opposite the statues. Infuriated by the mother's amply endowed proportions, they complained to the press. In June the London *Evening Standard* gave front-page attention to the 'outrage', declaring that Epstein's carvings were 'a form of statuary which no careful father would wish his daughter, or no discriminating young man, his fiancée, to see'.[21] Epstein, still at work with his carving assistants on scaffolding in front of the building, was soon visited by the police. The BMA quickly became a metropolitan scandal, and the *British Medical Journal* was amazed to discover that 'the whole Strand opposite was packed with people, most of them girls and young men, all staring up at the statues'.[22] The Chairman of the BMA began to panic, especially when the Church joined the assault with Father Bernard Vaughan's claim that Epstein was trying 'to convert London into a Fiji

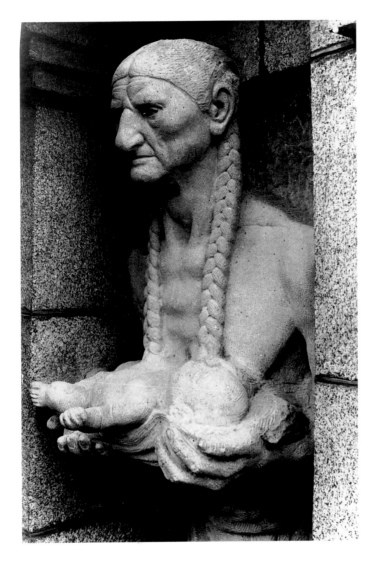

6 *New-Born* (detail),
British Medical
Association Building
1908
Portland stone

island'.[23] Fortunately, however, a counter-attack was mounted by an impressive shoal of sculptors, critics and museum directors. Voices as influential as Roger Fry and Sir Charles Holroyd, the Director of the nearby National Gallery, argued that the figures were admirably austere. Epstein was allowed to complete the rest of his carvings undisturbed.

But he could not indulge in a sense of triumph. This first, bruising encounter with British philistinism, xenophobia and prudish hostility made him vulnerable to further attacks throughout his life. Twenty long years would elapse before he received another architectural commission, and his name was now synonymous with modern art at its most inflammatory. He came to depend even more on the devoted support of his wife Peggy, an ardent left-wing Scots Nationalist whom he had met at the home of the Belgian anarchist publisher Victor Dave and married in November 1906.

A positive outcome of the BMA scandal was a strengthening of Epstein's

new friendship with Eric Gill, who defended the venture by claiming that the Strand statues 'attempted to rescue sculpture from the grave to which ignorance and indifference had consigned it'.[24] Both men were committed to the cause of regeneration, even if they had not yet produced anything that broke away decisively from the older generation's involvement with the classical and Renaissance tradition. They discovered a mutual urge to return to the prehistoric origins of sculptural expression, collaborating on a visionary plan for a titanic temple to be erected in the Sussex country-side. In the autumn of 1910 Gill underlined the primordial nature of their ambitions by referring to the venture as 'a great scheme of doing some colossal figures together (as a contribution to the world), a sort of twentieth-century Stonehenge'.[25]

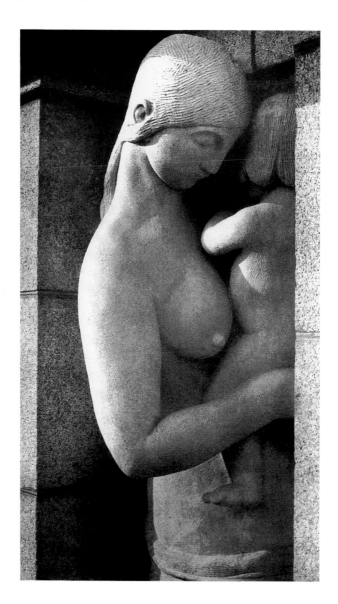

7 *Maternity* (detail).
British Medical
Association Building
1908
Portland stone

Although the plan was never realised, a number of surviving works indicate the likely character of the temple project. Until he entered into his close alliance with Gill, Epstein had only a half-hearted commitment to carving. Even the BMA figures were modelled in the studio, cast in plaster and then taken to the Strand before being copied in Portland stone, largely by a firm of architectural carvers.[26] Now, however, Epstein started to work directly in stone. Executing another head of Romilly John, he distanced himself from the earlier modelled portrait and produced a far sterner and more hieratic image (fig.8). By asking Gill to incise the austere, monosyllabic name 'ROM' on its base, Epstein drew attention to the elemental simplicity of the entire carving. For the naturalism of the earlier bronze portrait has now dropped away. This purged head transforms the boy into an embodiment of what Epstein described as 'the Eternal Child'.[27] He appears to grow out of the limestone block, and its rectangular identity is retained with uncompromising severity below Romilly's neck. The simplified, god-like features suggest a debt to oriental and above all Egyptian art, sources far removed from the classical precedents still venerated by British sculptors. Moreover, the defiantly hand-chiselled quality of the work announces Epstein's new commitment to a direct physical engagement with his chosen material. The decision to leave so much of the original block as an integral part of the finished work is tantamount to a proclamation. Henceforth, Epstein would always allow the innate character of the stone to help him shape the image it harboured.

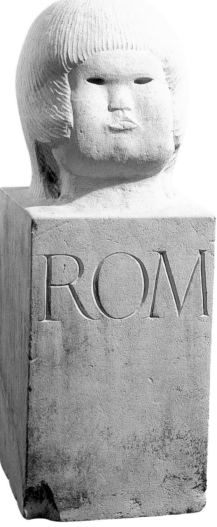

8 *Rom – Second Version* 1910
Limestone
h.87.5 (34½)
Inscription by Eric Gill
National Museums and Galleries of Wales, Cardiff

Carvings like *Rom* did nothing to endear Epstein to establishment opinion. 'It was at this period', he recalled, 'that I was proposed for membership of the Royal Society of British Sculptors, by Havard Thomas. I was rejected.'[28] Epstein had set himself on a lonely path, one that would earn him an appalling amount of vilification in the years ahead. But for the moment, at least, he was sustained by his growing involvement with Gill and their 'Stonehenge' plans. Writing one of the first sympathetic appraisals of Epstein to appear in a book, C. Lewis Hind reported in *The Post Impressionists* that *Rom* was intended as 'one of the flanking figures of a group apotheosising Man and Woman, around a central shrine, that the sculptor destines in his dreams for a great temple'.[29] It is a tantalising reference, clearly derived from remarks Epstein himself had

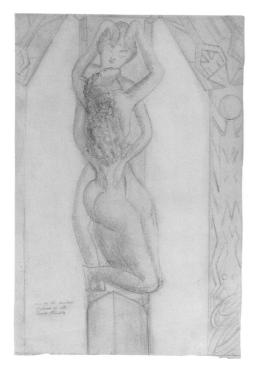

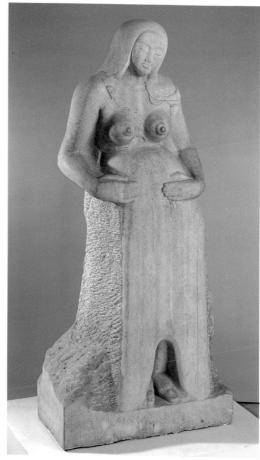

*9 Study for One
of the Hundred
Pillars of the Secret
Temple c.*1910
Pencil on paper
42 × 25.5 (16½ × 10)
Private Collection

made. We know little more about how he envisaged the figures within the proposed building, but it is safe to assume that his thinking about the project was dominated by an obsession with virility, fecundity and procreation.

Gill, who described Epstein as a man 'quite mad about sex',[30] proved his own willingness to explore a similar obsession in *Ecstasy*, an astonishingly explicit relief carving of the sexual act. Although Epstein never went so far as to make a sculpture of a copulating couple, he did outline a similar subject in a frankly erotic drawing inscribed *One of the Hundred Pillars of the Secret Temple* (fig. 9). Such images could never have been displayed in a public gallery, and Gill made clear that their Stonehenge scheme had the prime advantage of setting them 'free to do all we wanted without the fear of hurting anybody's feelings [or having] our figures smashed up by some damned fools who didn't choose to like them'.[31] The National Vigilance Association would be far away from the secluded valley where they planned their visionary edifice.

All the fragmentary evidence indicates that the temple's principal stimulus was derived from Indian art. In 1911 Gill declared that 'the best

route to Heaven is via Elephanta, and Elura [sic] & Ajanta'.[32] Judging by Epstein's monumental carving *Maternity*, commenced in 1910 and left unfinished, he might have agreed (fig.10). The burgeoning sensuality of Hindu sculpture surely helped to determine both the pose and the conspicuous ripeness of this figure. She makes her predecessor on the BMA building seem modest by comparison, and clasps her swollen stomach with such absorption that she seems oblivious of anything else. But *Maternity*'s lack of finish in so many areas ensures that Epstein's chisel-marks are proclaimed with unusual rawness. He may well have deliberately abandoned it, as an implicit reproof to all those senior British sculptors who polished the untroubled surfaces of their suave, gleaming stones. Epstein was not afraid to expose signs of struggle. He delighted in emphasising his manual engagement with the material, and exhibited the figure as *Maternity (Unfinished)* in 1912.[33] He also made sure that the robe's verticality and flatness, contrasting so unexpectedly with the globular breasts and strands of loose garment coursing down towards her provocative buttocks, honour the identity of the block he carved. Viewed from the sides, the lower half of *Maternity* discloses the extent of his determination to respect the original form of the Hoptonwood stone.

Even taller than this carving, and hewn from the same material, is a grand *Sun God* relief (fig.11). Not exhibited in Britain since the 1930s, and now incarcerated in a New York storeroom,[34] this arresting presence has never received the recognition it deserves. But when Epstein carved it, probably as a central embodiment of male potency for the temple venture, *Sun God* was an audacious achievement. With commanding limbs outstretched and genitals brazenly exposed, the lithe young deity exudes virile authority. Since Epstein deepened the relief twenty years later, the figure must originally have been shallow enough to look as if it were growing out of the block. Even today, seen in the shadows of the Metropolitan Museum of Art's depot, the umbilical link between figure and ground is still evident – most of all in the spectacular mane of Egyptian tendrils flowing back from his imperious face until they merge with the stone behind.

The same principle governs Epstein's most elaborate and ambitious carving of the period. It originated in 1908, soon after he finished the BMA statues. They impressed Oscar Wilde's literary executor Robert Ross, who had been charged with the task of finding a sculptor for the Wilde tomb in Père Lachaise Cemetery, Paris. Ross had already admired the homoerotic intensity of Epstein's drawings for Whitman's *Calamus*, and must have hoped for a funerary monument imbued with the same Symbolist melancholy. Preliminary pencil studies, showing two elongated youths resting their sorrowful heads on an unadorned stone stele, suggest that Epstein at first intended to fulfil Ross's expectations. He even modelled an over-lifesize figure called *Narcissus*, who raised one slender arm above his head in theatrical mourning. But then, quite suddenly, the work was scrapped. Epstein must have grown dissatisfied with its *fin-de-siècle* attenuation, and decided to search for a less sentimental, carved alternative.

Focusing now on Wilde's poem *The Sphinx*, he probably decided that his

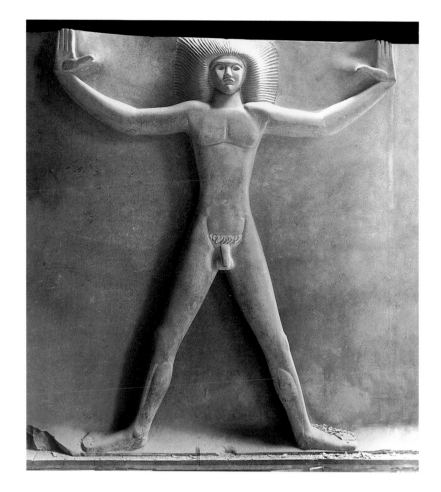

interest in Egyptian art lent itself to the representation of an airborne figure whose wings, in Wilde's words, rose 'high above his hawk-faced head'. This is the Egyptian god Ammon, the Sphinx's imagined lover. And in an extraordinary drawing, Epstein showed the serpentine, diminutive form of the phallic Sphinx resting on Ammon's shoulder in order to whisper 'monstrous oracles into the caverns of his ears'. Below them, a frieze of Vices embracing and licking each other reinforces the lascivious mood, indicating that Epstein intended the tomb at this stage to be as sexually unfettered as anything he was carving for the putative Sussex temple. But the crucified Christ rising above Ammon's head proves that sacrifice and redemption also played their part in this complex image.

In the end, though, carnality gave way to airborne enigma (fig.12). Epstein turned the figure into 'a flying demon-angel'[35] whose extravagant Buddha-like head-dress ruled out the possibility of any seductive whispering in the ear. Inspired by the great Assyrian man-headed bull carvings in the British Museum, he transformed the wings into a streamlined expression of flight. Small figures symbolising Intellectual Pride, Luxury and Fame replaced Christ on the head-dress, but the demon angel's face looks

profoundly fatigued. In this respect, his expression echoes Wilde's reference to the Sphinx's 'thousand weary years', and a mood of resignation prevails. Even so, Epstein's decision to suspend his figure gives the *Tomb* a remarkable sense of resilience. Like *Rom* and the *Sun God* before him, the demon angel appears to grow out of the stone, but this time he hovers gracefully in space as well.

The completed carving impressed Henri Gaudier-Brzeska, a young French artist recently settled in London and soon to be ranked with Epstein as a pioneering force in British sculpture. Writing to his mentor Dr Uhlemayr, Gaudier enclosed a vigorous ink sketch of the *Tomb* and declared that 'the whole work is treated – strongly, filled with insuperable movement and delicate feeling, in the expression and the medium – a piece of sculpture which will live for ever'.[36] Gaudier warmed to Epstein's insistence on innovation, his departure from classical precedent and, above all, his determination to let the particular character of his material play a vital role in shaping the identity of the work he produced. But Epstein was eleven years older, and armed with far greater experience. When he asked his young visitor 'if he carved direct', Gaudier was 'afraid to acknowledge that he hadn't'. As a result, 'he hurried home and immediately started a carving'.[37] The incident amused Epstein, who recalled that his 'relations with Gaudier were very friendly. We were interested in each other's work. In the French fashion of the younger to the older artist he wrote to me and addressed me as Cher Maître.'[38]

When the Wilde carving was displayed in his London studio in June 1912, prior to its installation at Père Lachaise, Epstein found himself praised for his engagement with his material. After pillorying him years earlier over the BMA statues, the *Evening Standard* now opined that the *Tomb* 'is as reserved in execution as it is monumental in conception ... there is nothing to destroy the effect of a rectangular block of stone that has felt itself into expression'.[39] The planar austerity of the plinth, bearing only a simple inscription designed by Gill,[40] reinforced the sense of solemnity. But the *Pall Mall Gazette* emphasised the work's audacity, and described Epstein as 'a Sculptor in Revolt' who believes that 'the carver's idea must be born in the marble and spring directly from it'.[41]

Such supportive responses must have encouraged Epstein to believe that the opprobrium heaped on the BMA statues was being replaced by a more enlightened understanding. 'I want to carve mountains',[42] he eagerly informed his American patron John Quinn, in the hope that the *Tomb*'s success might lead to more commissions for monumental work. He was still in thrall to the dream that had inspired his Stonehenge venture with Gill, and Jack London's visionary scheme to make a marble city in Arizona excited the epic side of his imagination. Writing to Quinn about the Arizona project, Epstein declared that 'a sculptor dreams of that great temple or city to be built, carved, a work to last a lifetime, something progressive, imminent, superhuman, in which you could put all that you imagine, desire, where there is free opportunity for a large constructive scheme ... many young men of talent and ardour would be given an opportunity and

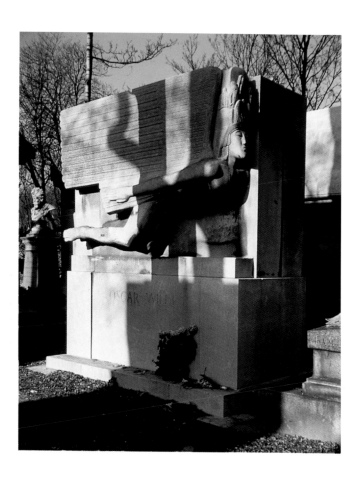

12 *The Tomb of Oscar Wilde* 1909–12 Hoptonwood stone Père Lachaise Cemetery, Paris

as well a large body of able craftsmen would be trained, as in the great periods of sculpture, in India, Egypt, the Middle Ages or in Mexico'.[43]

Once the Wilde sculpture was sent to Paris, however, troubles began. Rejecting its status as a work of art, the French customs demanded a punitive import duty payment. Then, after it had been installed in Père Lachaise, Parisian officials bridled at the figure's nakedness. 'Imagine my horror when arriving at the cemetery', Epstein wrote in September, 'to find that the sex parts of the figure had been swaddled in plaster! and horribly. I went to see the keeper of the cemetery and he tells me that the Prefect of the Seine and the Keeper of the Ecole des Beaux Arts were called in and decided that I must either castrate or fig leaf the monument! What am I to do? Here is the Strand business all over again.'[44]

With the support of friends like Brancusi, Epstein succeeded in removing the tarpaulin draped over the monument. The effort involved in counter-attacking prudish Gallic censorship distracted him from his own work. But during his Paris sojourn he became close to like-minded artists of his own generation, who were even more radical in their desire to overhaul European sculpture. Brancusi, himself the carver of a funerary monument in Montparnasse Cemetery,[45] would have spurred Epstein's determination to strip his work of all unnecessary detail. The Montparnasse carving, a

purged version of *The Kiss*, achieved a far greater simplification than the Wilde tomb. Brancusi would never have indulged in the excessive elaboration of the flying figure's head-dress, nor lavished so much attention on the articulation of his wing-feathers. But Epstein was beginning to move towards a greater simplicity of his own. One of the small works associated with the Sussex temple, a limestone *Crouching Sun Goddess* (fig. 13), had already shown a kinship with carvings like Brancusi's 1908 *Wisdom of the Earth*. The two men had much in common, not least in their fascination with 'primitive' art.

On a personal level, though, Epstein found Modigliani more congenial company. They spent a great deal of time with each other in Paris, and tried to find a shed on the Butte Montmartre where they could work together. Epstein never forgot the sight of Modigliani's studio, 'filled with nine or ten of those long heads which were suggested by African masks, and one figure. They were carved in stone; at night he would place candles on the top of each one and the effect was that of a primitive temple.'[46] Although Epstein was never tempted to vie with the elegant elongation of Modigliani's forms, a carving called *Sunflower* (fig. 14) surely owes a debt to the Italian sculptor. Compared with the *Sun God* relief two years earlier, this mesmeric head appears brutally shorn of detail. The almond eyes are summarised with an economy that both Modigliani and Brancusi would have approved, while the mouth is eliminated altogether. Even so, *Sunflower*'s ball-like head and sturdy neck are thicker than anything Modigliani produced. Epstein's robust, monumental forms are far from anorexic, and the aggressive force of the segments exploding from *Sunflower*'s skull is wholly removed from Modigliani's gentle vision. They have the rude vigour of dog-tooth carvings in Romanesque churches, and help to explain why, within a year, Epstein would become preoccupied with the more eruptive forms of machine-age dynamism.

Back in London, he had already found himself allied with a rising generation of innovative young artists through work on a remarkable commission. From the moment it opened in June 1912, the Cabaret Theatre Club became notorious for the paintings and sculpture enlivening its principal arena – the Cave of the Golden Calf. Visitors to London's first 'artists' cabaret', situated in appropriately underground premises in a warehouse basement off Regent Street, discovered inflammatory images assailing them on the walls, pillars and stage. The new art, previously confined to gallery surveys like Roger Fry's Post-Impressionist exhibitions, was here unleashed in a cavern unashamedly devoted to the pleasure principle. Madame Frida Strindberg, who founded the Club, was an exuberant Austrian writer once married to the playwright August Strindberg. With great audacity, she invited five of the most promising young painters and sculptors in London to make the Cave into a showplace for advanced art.[47] While Charles Ginner and Spencer Gore produced murals of a 'primitive' South Seas paradise, Wyndham Lewis painted a monumental and eruptive canvas called *Kermesse* for the staircase. Gill carved a free-standing gilded sculpture of the biblical calf itself, a symbol

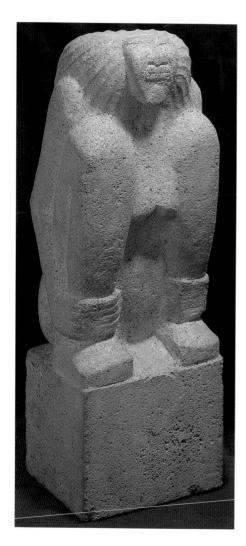

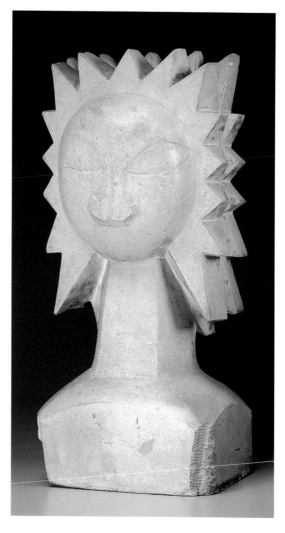

13 *Crouching Sun Goddess* c.1910
Limestone
h.37.5 (14¾)
City of Nottingham Museums

14 *Sunflower*
1912–13
San Stefano stone
h.58.5 (23)
National Gallery of Victoria, Melbourne. Felton Bequest 1983

of profanity. And Epstein covered the two large iron pillars supporting the ceiling with plaster images, half human and half animal, painted in clamorous colours.

Nothing now remains of his work at the Cabaret, which he later described as 'a very elaborate decoration'.[48] But it must have helped to heighten the barbarous impact of an interior where the golden calf, also carved in relief by Gill, was deployed as the unifying symbol of a club given over to hedonism at its most defiant – in art, music, drama and dance. One astonished reviewer decided that the brazen arena evoked 'the primitive simplicity of the days when art was in its infancy. It was, after all, on bones and on the walls of caves that the artistic instinct found its first expression.'[49] Those words would prove especially prophetic in terms of Epstein's development. Over the next few years, he returned to the very origins of three-dimensional form in his thoroughgoing search for sculptural renewal.

2
DYNAMISM AND DESTRUCTION

Only after returning from France did Epstein settle into a sustained exploration of his aims. He later blamed his inability to work in Paris on practical difficulties, and complaints from neighbours about his incessant hammering. But the truth may be that Brancusi's awesomely single-minded example inhibited Epstein at first. He needed time to prepare himself for the extreme purging of form that Brancusi was already pursuing with absolute conviction, bent on discarding everything except sculptural essence. Epstein afterwards remembered how the Romanian 'would pluck at the back of his hand and pinch the flesh, "Michelangelo", he would say, "beef steak!"'[1]

As well as implying that Epstein should beware of sculptural bulk, Brancusi offered some excellent practical advice. He would 'exclaim against café life and say that one lost one's force there'.[2] Epstein agreed, and soon after returning to England he found a cottage called Bay Point in Pett Level, a secluded Sussex coastal village. Here, safely removed from the myriad distractions of the metropolis, he found himself able to 'look out to sea and carve away to my heart's content without troubling a soul'.[3] The isolation,

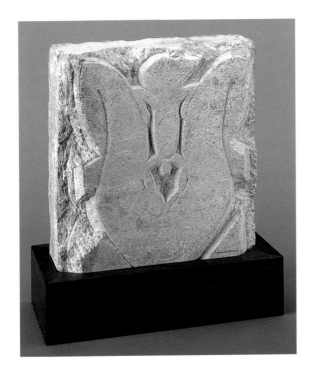

15 *Birth c.1913*
Stone
30.6 × 26.6 × 10.2
(12 × 10½ × 4)
Art Gallery of
Ontario, Toronto

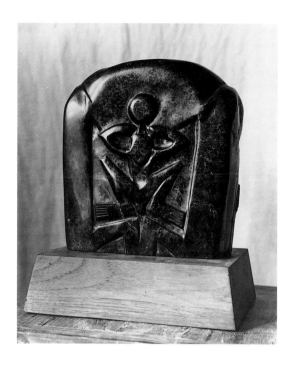

16 *Flenite Relief*
1913
Serpentine
30.5 × 28 × 9
(12 × 11 × 3½)
Private Collection

no less than his proximity to an immense stretch of water, may well have stirred memories of that formative sojourn on the shores of Greenwood Lake, when the idea of becoming a sculptor began to define itself in his mind. At all events, Pett Level's surroundings stimulated him to embark on a period of exceptional achievement. The next few years would in many ways prove the high point of his entire career.

A new sense of primeval grandeur informs even the smallest and least finished of the carvings he now produced. An incomplete *Birth*, hesitant enough to suggest that it is among the earliest works executed at Pett Level, nevertheless benefits from the forceful presence of the unchiselled stone (fig.15). The mother's inverted limbs, struggling to let her baby emerge from the vagina, gain some of their tension from the rough surfaces around them. A related ink drawing,[4] where the mother widens her mouth in an agonised yell, emphasises just how violent Epstein thought the arrival of new life could be. For the offspring, however, it is a triumphant emergence.

Birth is enacted once more on one side of a more complex and refined *Flenite Relief* (fig.16). But the baby now clasps an ovoid form with great gravity, relishing its primal simplicity as much as Epstein himself values the slab-like identity of his material. Without unduly disturbing the dark flenite – the nickname he gave to his green serpentine stone – he transforms it into the body of a woman whose inverted head and torso appear on the other side. Her forearms surmount the relief, crossing each other with a directness reminiscent of the interlocked arms in Brancusi's *The Kiss* at Montparnasse Cemetery. Unlike Brancusi, though, Epstein incorporates in this surprisingly elaborate carving virile columns on the edges of the block.

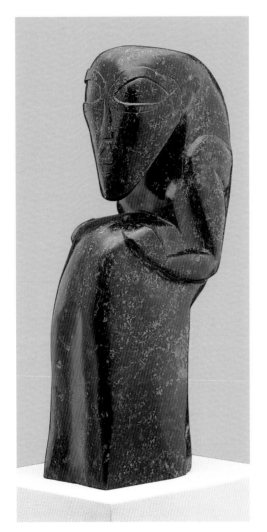 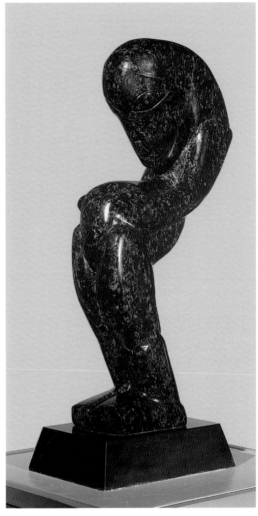

The role played by the phallus in the procreative mystery is only acknowledged by implication in other works from the Pett Level period. For Epstein now decided to concentrate on the pregnant female form in an outstanding pair of flenite carvings (figs.17, 18). The larger of the two, *Figure in Flenite*, owes a debt to Polynesian sculpture. Her neck cranes forward in an anxious manner, as if determined to fend off danger from the child growing within her belly. The solidity of her dress lends her a certain strength, but this woman conveys an overall sense of inhabiting a perilous, archaic world where defensiveness is inevitable.

In Paris, Brancusi had warned Epstein against imitating the 'primitive' carvings that nourished both men's work. The smaller *Female Figure in Flenite* puts this advice into practice, countering Polynesian influence with a more individual feeling for the mother's rapt involvement with her unborn child. Her meditative head is suspended directly over the pregnant stomach, and the woman's upper body curves back from her sturdy legs in

17 *Figure in Flenite* 1913
Serpentine
h.60.9 (24)
Minneapolis
Institute of Arts

18 *Female Figure in Flenite* 1913
Serpentine
h.45.7 (18)
Tate Gallery, London

an arc of passionate maternal protectiveness. The outcome is one of Epstein's most tender, concentrated and affecting works. But when he staged his first solo show, at London's Twenty-One Gallery in December 1913, an incensed critic dismissed the flenite figures as 'rude savagery, flouting respectable tradition – vague memories of dark ages as distant from modern feeling as the lives of the Martians'.[5]

Such hysterical attacks prompted the publication of a lengthy, indignant defence by the philosopher and poet T.E. Hulme, the most partisan of Epstein's friends. 'Modern feeling be damned!' he exploded in the Christmas Day issue of *The New Age*. 'As if it was not the business of every honest man at the present moment to clean the world of these sloppy dregs of the Renaissance.'[6] Learning from so-called primitive art was a necessary stage in this radical, purgative process, and Epstein showed no hesitation in using an African source for a polemical sculpture called, in a quotation from Job, *Cursed Be the Day wherein I Was Born* (fig.19). Deriving its pose from wood and brass ancestral figures, of the kind he had begun to buy for his own, subsequently renowned collection of non-western art,[7] Epstein modelled a plaster figure of a black child screaming against his fate. As a Jew whose parents had suffered from anti-semitic persecution in their native Poland, Epstein harboured an instinctive sympathy for victims of racial intolerance. He was at his most protesting in this jagged image, whose ferocity was strengthened by his decision to paint the child's body scarlet.

On the whole, though, maternity dominated Epstein's imagination at this fruitful stage in his career. The peaceful isolation of Pett Level ensured that his carvings took on a remarkable tranquillity, nowhere more than in the marble *Mother and Child* (fig.20). Placed next to each other, so that their heads can be dramatically contrasted, woman and offspring both exude a solemn stillness. The mother's attenuated African concavity, doubtless inspired by Epstein's recent encounter with a Fang reliquary carving known as the Brummer head,[8] could hardly be further removed from her infant's circular convexity. But they are united by the sculptor's insistence

19 *Cursed Be the Day wherein I Was Born* 1913–14
Painted plaster and wood
h.115.5 (45½)
Probably destroyed

on defining their features in a minimal way. Moreover, the simply incised fingers of the mother's protective hand help to alleviate the strange, disquieting air of separateness.

Facial features are jettisoned even more ruthlessly in the first version of his marble *Venus* (fig.21). Her blankness is impenetrable. Pendulous breasts indebted to African art are suspended above her pregnant belly, and in this respect she is surely intended as an impersonal embodiment of fertility. Epstein reinforces this interpretation by placing her on a pair of copulating doves. Indeed, birds and woman are conjoined in stone, stressing her oneness with the natural world. Only the awkwardness of her bent legs, combined with the tilt in the upper dove's body, unsettles the carving's blanched calm.

Epstein's awareness of this instability may well have prompted him to embark on a second, more successful *Venus* soon afterwards (fig.22). Twice the height of her predecessor, she is also slimmer and more refined. But her cool, hieratic dignity is accompanied by greater sensuality. In an attempt to integrate the *Venus* more satisfactorily with the doves, Epstein makes her legs lean against the cock's comb. Its tips are inserted in the woman's parted calves, while its tail rises as a manifestation of arousal. Viewed from

20 *Mother and Child* 1913–14
Marble
43.8 × 43.1 × 10.2
(17¼ × 17 × 4)
Museum of Modern Art, New York.
Gift of A. Conger Goodyear

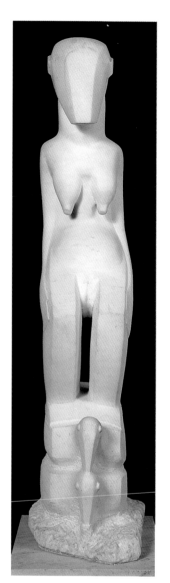

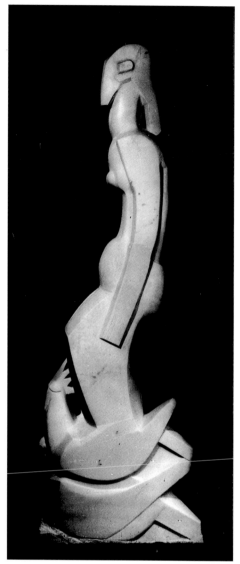

21 *Venus – first version* 1913
Marble
h.123.2 (48½)
Baltimore Museum of Art. Alan and Janet Wurtzburger Collection

22 *Venus – second version* c.1914–16
Marble
h.235.5 (92¾)
Yale University Art Gallery, New Haven. Gift of Winston F.C. Guest 1927

the front, this 'beautiful tower of white marble'[9] seems the most poised and seductive carving produced during the Pett Level period. Epstein disclosed some of the profound personal satisfaction he derived from this *Venus* in a letter to his composer friend Bernard van Dieren, confessing that 'few will see what I've expressed or aimed to express in it; and if they did they would be unholily shocked. What sacrilege to present to public view that work which I for a long summer privately and almost in secrecy worked at for my own pleasure.'[10]

Those words could be applied equally well to his sequence of dove carvings (figs.23–5), executed independently of the *Venus* figures. In the earliest version, the male dove has only just alighted on his companion's back. Sexual appetite may be implied, but the ungainliness of the relation-

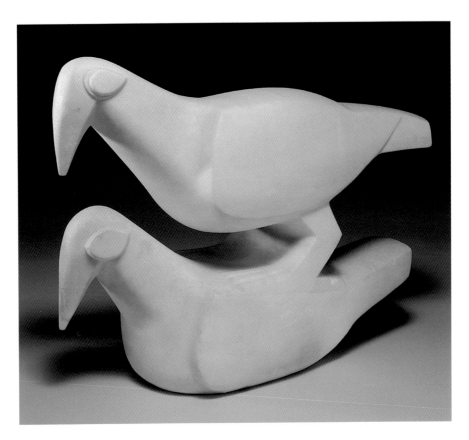

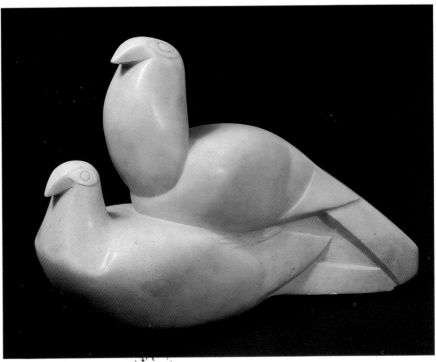

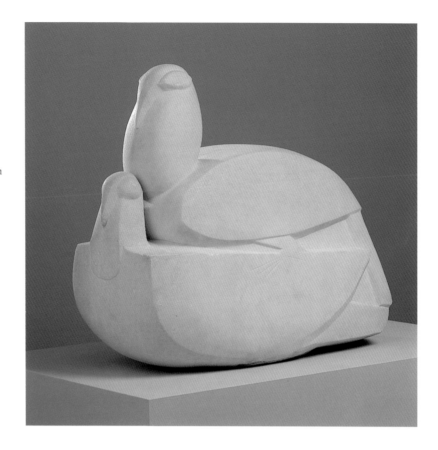

ship between them militates against sensuality. The greater success of the other two carvings in the series suggests that Epstein learned from Brancusi's *Three Penguins*, which he may have seen in the sculptor's Paris studio. Epstein continued to visit Paris in 1913, most notably when he accompanied the young painter David Bomberg on a trip to select Jewish avant-garde artists for an exhibition at the Whitechapel Art Gallery.[11] The notable compactness and succinct expression of intimacy in *Three Penguins* are certainly qualities found in Epstein's second pair of *Doves*, where the male has settled on top of his partner and started mating. His tail flows down in an uninterrupted curve to touch hers, accentuating the *frisson* between them. And Epstein ensures that both birds' necks rise upwards, plump with desire. The graceless jutting forward in the first version has been replaced, here, by a far more convincing, libidinous alternative.

Conveying lust was not Epstein's overall priority in the *Doves* series, however. As the final version attests, he wanted to arrive at a closer accord between the two bodies. In this carving, the sense of a solid block has been retained. Very little space is opened up between the birds: they fuse, in their concentrated intensity, into a relatively undivided mass of Parian marble. Epstein is at his most assured and rigorous here. His intervention in the stone is pared to a minimum, and the urgency of sexual desire has given way to absolute stillness. Writing about this sequence, Ezra Pound

declared that 'these things are great art because they are sufficient in themselves ... Representing, as they do, the immutable, the calm thoroughness of unchanging relations, they are as the gods of the Epicureans, apart, unconcerned, unrelenting.'[12]

By the time Epstein exhibited the second version of *Doves*, in a Post-Impressionist and Futurist Exhibition organised by Frank Rutter at the Doré Galleries in October 1913, Pound had capitulated entirely. The two men shared American origins, and both were increasingly committed to the need for innovation, in poetry and sculpture alike. Around 1912 Epstein had directed Pound's attention to Wyndham Lewis, arguing that 'Lewis' drawing has the qualities of sculpture'.[13] Indeed, Epstein was instrumental in persuading Pound that a new initiative in modern British art was worth supporting. 'So far as I am concerned,' Pound wrote, 'Jacob Epstein was the first person who came talking about "form, not the *form of anything.*"'[14] And by November 1913 he had convinced himself that 'Epstein is a great sculptor. I wish he would wash, but I believe Michel Angelo *never* did, so I suppose it is part of the tradition.'[15]

Several of Epstein's most outstanding works from this period have failed to survive. They include *Bird Pluming Itself*, a carving especially admired by Pound who described it as 'a cloud bent back upon itself'.[16] Even more regrettable is the loss of a highly ambitious figure carving – a formidable *Mother and Child* hewn from an immense block of granite. Only one photograph exists of this major sculpture, which was apparently destroyed in 1923 (fig.26).[17] Epstein leans against the unfinished stone, hammer and chisel in hand. His proximity to the carving is striking. It suggests that he saw himself as the male part of a group otherwise dedicated to maternity. The antecedents of *Mother and Child* lie in his earlier *Birth* and *Flenite Relief*. This time, however, the offspring is a substantial figure in his own right. He asserts his identity in front of the woman, threatening to mask her. But the manifest roughness of the maternal image, in the photograph at least, rules out a proper assessment of her true significance. Only the monumentality of the carving is beyond dispute. It remains impossible to tell how much further work had been executed on the sculpture when Epstein displayed it as *Carving in Granite. 'Mother and Child'. Unfinished.*[18] The first three words of the title emphasised its material presence, as an image hewn in hard

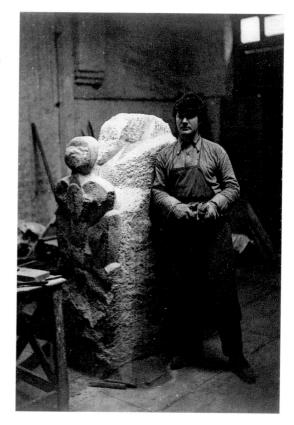

26 Epstein in his studio with *Mother and Child* 1915–17 Granite, over life-size
Probably destroyed

stone. It must have been intended to stand in dramatic contrast to the refinement of the *Doves* and *Venus* carvings, as a reminder that Epstein was, at his most ambitious, a sculptor of raw, elemental power.

The most haunting and original work he executed during this period also explored the relationship between a parent and child. In this instance, though, the offspring takes the form of an embryo and the parent is a man. *Rock Drill* appears initially on a sheet of pencil and crayon studies, probably executed in 1913 (fig.27). The presence there of a small, outline drawing for the first version of the *Doves* series is reinforced, in the centre, by the image of a woman with a sun-burst head-dress. She is copulating with the inverted male figure below her. Epstein never produced a sculpture of this subject, which would have been even more sexually provocative than Gill's earlier *Ecstasy*. But he did pursue the idea of making a sculpture charged with virility. On the right of the sheet, a penile form thrusts upwards like a rocket from an explosive base. On the left, a man with bent, straining limbs asserts his angular strength. Clearly indebted to totemic carvings, it shows at the same time how Epstein was moving from 'primitivism' towards a mechanistic vision of humanity.

Hulme would have been delighted to witness this development. It accorded with his own conviction that 'the new "tendency towards abstraction" will culminate, not so much in the simple geometrical forms found in archaic art, but in the more complicated ones associated in our minds with the idea of machinery'.[19] He had already found elements in the *Tomb of Oscar Wilde* that led him, as Epstein recalled, to turn it 'into some theory of projectiles'.[20] And now Hulme discovered that the sculptor was working on an ambitious proclamation of his new-found involvement with the machine-age world.

Several large and elaborate drawings testify to the important role *Rock Drill* played in Epstein's pre-war imagination. In *Winged Figure*, the mechanistic man does indeed appear to be metamorphosing from the 'demon-angel' on the Wilde tomb. But he soon assumed vertical form, stimulated no doubt by Epstein's encounter with a drilling machine while visiting a quarry in search of stone (fig.28). The most up-to-date drill developed for rock-cutting was a revolutionary implement in the mining industry.[21] If Epstein saw it in action, he is likely to have been impressed by the drill's deafening force, speed and effectiveness. In early studies for the sculpture, he shows driller and machine mounted on a tripod stand. The drawings accentuate the grandeur of the machine, resting on a pyramidal base. Seen from the front, the man mounted on the tripod assumes a heroic stature, looking upwards at the centre of an awesome cavity in the rock. But in a rear view he bends to his task, concentrating on the effort involved in wielding the power of his instrument.

A further study, of the drill head striking the rock, shows how fascinated Epstein became with the machine itself. Just as some of the Futurists had experimented with the kinetic potential of their work, he even thought of 'attaching pneumatic power to my rock drill, and setting it in motion, thus completing every potentiality of form and movement in one single work'.[22]

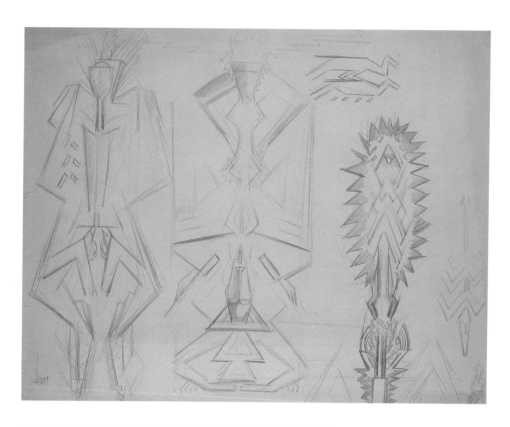

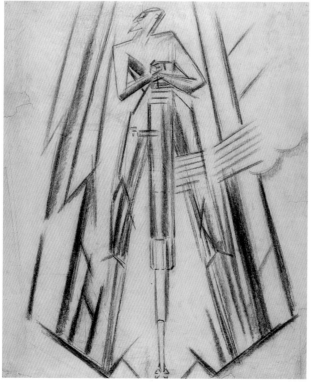

27 *Six Studies for 'Rock Drill',*
'Venus' and 'Doves' c.1913
Pencil and crayon on paper
45.5 × 58.5 (18 × 23)
Courtesy Anthony d'Offay
Gallery, London

28 *Study for 'Rock Drill'*
c.1913
Charcoal on paper
64.1 × 53.3 (25 × 21)
Tate Gallery, London

In the end, though, Epstein shared Wyndham Lewis's abhorrence of blurred movement. They both preferred hard, clearly defined structures, and in this respect Epstein was in sympathy with the emerging aims of the Vorticist group. Hence his willingness to reproduce two drawings in the first issue of the belligerent Vorticist magazine *BLAST*. One, a tense study called *Birth*, revealed the close links between the flenite women and the driller, who likewise harbours new life within his protective body.

The flenite carvings could not, however, have prepared anyone for Epstein's astonishing decision to make a real machine an integral part of the *Rock Drill* sculpture. At a time when Marcel Duchamp had only recently nominated a bicycle wheel as a work of art, Epstein committed a similar heresy by pressing ahead with 'the purchase of an actual drill, second-hand, and upon this I made and mounted a machine-like robot, visored, menacing, and carrying within itself its progeny, protectively ensconced'.[23] Even today, the audacity of this sculpture is still bracing. But in 1913, Epstein was almost alone in proposing that a machine could play a legitimate part in a work of art. Although he stopped short of Duchamp's extremism, and combined the ready-made drill with a man-made driller in

29 Photograph of the unfinished *Rock Drill* in Epstein's studio, c.1913

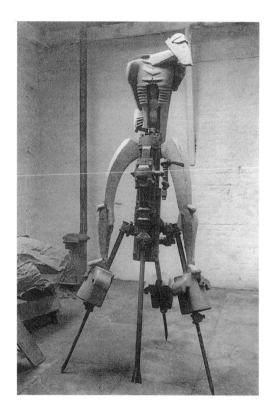

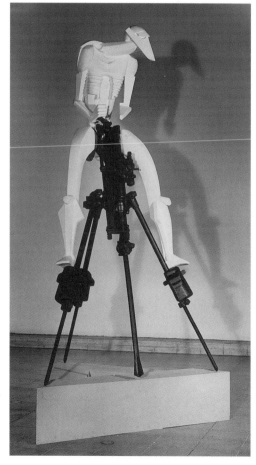

30 Reconstruction by Ken Cook and Ann Christopher of the *Rock Drill*, after the dismantled original 1913–15
Polyester resin, metal and wood, h.250.1 (98½)
Birmingham Museums and Art Gallery

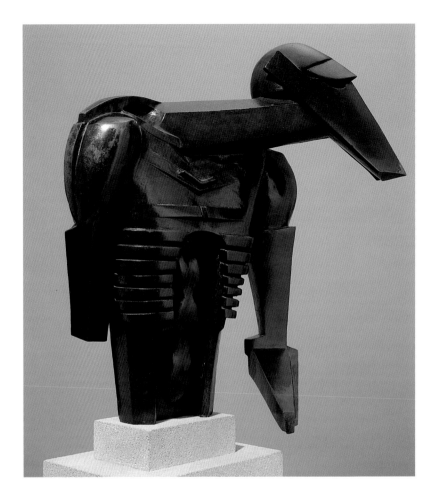

31 *Torso in
Metal from the
'Rock Drill'*
1913–16
Bronze
70.5 × 58.4 × 44.5
(27¼ × 23 × 17½)
Tate Gallery,
London

white plaster, Epstein must have known that his sculpture would affront
most of its viewers.

He made no attempt to pretend, in this first version of *Rock Drill*, that the
machine had been altered in any way (fig. 29). He did, however, ensure that
the driller took on the angular, rigid dehumanisation of a world dominated
by mechanised power. Transformed by a visored helmet, his head juts for-
ward on its shaft-like neck. The body beneath seems to be made up of com-
ponents from some formidable engine. Even the legs, curving outwards into
the lines of a gothic arch, are tensile and armoured. The drill itself appears
to be an extension of the man's body, thrusting down like a mechanised
penis towards the ground. The only organic part of the sculpture is the
foetus embedded so incongruously within the figure's rib-cage. Although
exposed, it seems in this first version to be protected by the driller's hand
grasping the handle of the machine. The foetus is at this stage perched high
above the tripod, removed from immediate danger.

When Epstein exhibited the original *Rock Drill* for the first and only time,

at the London Group show in March 1915, most of the critics ignored the generative element. Preoccupied with his self-confessed 'ardour for machinery',[24] they were astounded by his temerity. 'He has accepted it all', wrote the *Manchester Guardian*'s reviewer, 'the actual rock drill is here in this art gallery. Mr Epstein has accepted the rock drill, and says frankly that if he could have invented anything better he would have done it. But he could not. One can see how it fascinated him; the three long strong legs, the compact assembly of cylinder, screws and valve, with its control handles decoratively at one side, and especially the long, straight cutting drill like a proboscis – it all seems the naked expression of a definite force.' But this sympathetic critic finally balked at the inclusion of a machine, declaring that 'even if the figure is to be cast in iron, the incongruity between an engine with every detail insistent and a synthetic man is too difficult for the mind to grasp'.[25]

Most of his fellow-reviewers were far less charitable. The *Observer*'s critic, P.G. Konody, decided that 'the whole effect is unutterably loathsome',[26] and *Rock Drill* even managed to offend some of Epstein's supporters. Augustus John, whose son had been the subject of the sculptor's early portraits, was so repelled that he denounced it as 'altogether the most hideous thing I've seen'.[27] Only Wyndham Lewis, writing in the second issue of *BLAST*, was perceptive enough to point out that *Rock Drill*'s 'lack of logic has an effectiveness of its own'. He realised that the sculpture had a dream-like strangeness, and concluded that it was 'one of the best things Epstein has done'.[28]

However much *Rock Drill* seemed like a bold sculptural expression of the Vorticists' theoretical insistence on 'the point of maximum energy',[29]

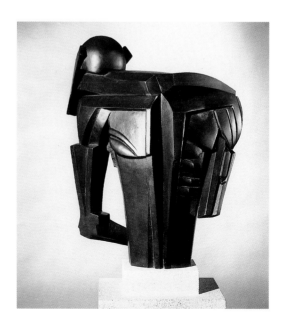

32 Back view of *Torso in Metal from the 'Rock Drill'*, 1913–16

Epstein refused to become a member of their movement. While Gaudier-Brzeska signed the Vorticist manifesto in *BLAST* and wrote a militant credo for the magazine, Epstein preferred, like his young friend Bomberg, to remain independent of all avant-garde groups. Besides, his attitude to the machine age began to change soon after he completed the first version of *Rock Drill*. The Great War had been decimating the young men of Europe for nine months by the time his sculpture went on display. The mechanistic dynamism celebrated in Epstein's fierce work had led to an unparalleled capacity to annihilate humanity. Gaudier was killed on a French battlefield in June 1915, and his death shocked many artists associated with the Vorticist circle into an awareness of the war's horror. The machine, hitherto seen by them as a prime agent of construction, now revealed itself to be the instrument of wholesale obliteration. The industrialised armaments unleashed during the First World War slaughtered soldiers and civilians in their millions, forcing innovative young artists to reconsider their attitudes.[30]

It was inevitable, then, that the war's apocalyptic course would prompt Epstein to make radical changes to *Rock Drill*. He may have wrestled with his own doubts about the aesthetic desirability of placing a ready-made object in a work of art.[31] But the principal reason why his sculpture suffered such drastic alterations lay in Epstein's increasingly mortified response to the war. He discarded the drill, and along with it the legs of the man who had controlled this violent invention. Deprived of his phallic weapon, the truncated driller was cast in gunmetal. But the transformation from plaster to a tougher material did not bolster his strength. On the contrary: the figure displayed in the London Group's summer 1916 exhibition looked melancholy and defenceless. Epstein called it *Torso in Metal from the 'Rock Drill'*, and did not even permit the man to retain the hand that once clasped the machine's handle (figs. 31, 32). His right arm has been lopped off above the elbow, leaving the remaining forearm to jut forward and hang uselessly in space. Unable to ward off an attack, this stooping driller is equally incapable of protecting his progeny. Deprived of its former lofty position, the foetus now seems pitifully vulnerable. The metallic ribs surrounding this half-formed child belong to a body as broken as the wounded soldiers returning from the Western Front in ever greater numbers.

Torso in Metal from the 'Rock Drill' effectively marks the termination of Epstein's involvement with the machine age. Compared with the overwhelming belligerence of Archipenko's *Boxers* or Duchamp-Villon's *Large Horse*, two other contemporaneous European sculptures charged with mechanistic energy, this injured figure resembles a victim. Never again would Epstein explore the dehumanised world where his plaster driller had once enjoyed such dominance. He began to recoil from avant-garde art, telling his New York patron John Quinn that 'you are inclined to overrate what you call advanced work; not all advanced work is good, some of it is damn damn bad'.[32] Epstein himself had never stopped modelling heads in a vigorously expressive idiom. His 1915 *Portrait of Iris Beerbohm Tree* shows how adroitly he could combine the gleaming, helmet-like abstraction of the

sitter's hair with an altogether more representational account of her features (fig. 33). And now, in the wake of *Rock Drill*'s savage dismemberment, he returned to a more figurative way of working.

His experience as a conscripted soldier probably hastened this development. Epstein failed in his attempt to obtain commissions as an official war artist and thereby escape military service. Sir Martin Conway, Director of the Imperial War Museum, approved of the proposal that Epstein should 'make a series of typical heads of private soldiers serving in the various contingents which make up the British army ... Jews, Turks, infidels, heretics and all the rest'.[33] But this ambitious multi-racial venture was apparently vetoed by a vituperative letter from the senior British sculptor Sir George Frampton, and the exasperated Epstein was consigned to a training barracks near Plymouth. Nervous collapse followed in spring 1918. When his regiment's departure for the Middle East was announced, he went missing on Dartmoor and ended up in hospital suffering from 'a wretched state of nerves'.[34] In the summer he was invalided out, and thereby avoided the fate of his champion Hulme, blown to pieces in the trenches. The manuscript of a book on Epstein vanished with him.

The loss of such an eloquent and stimulating supporter must have intensified Epstein's isolation. No one was prepared to commission the war memorial he longed to make, but he did manage to complete an unofficial monument called *Risen Christ* (fig. 34). There is nothing triumphal about this resurrection. With gaunt face and etiolated body, Christ emerges from death in a state of sombre stillness. He scarcely seems to have recovered

33 *Portrait of Iris Beerbohm Tree* 1915
Bronze
34.8 × 29 × 22.8
(13¾ × 11½ × 9)
Tate Gallery, London

from his martyrdom, and the winding sheet does not disguise the frailty of his limbs. Although the head was based on the ailing Dutch composer Bernard van Dieren, who would later write the first book on Epstein's work, the sculptor's own traumatic experience in the army surely informs *Risen Christ* as well. But if this figure might easily have suffered from 'complete breakdown',[35] as Epstein described his own plight on Dartmoor, he still has the resilience to hold out a hand and disclose the gashed palm. He points an 'accusing finger'[36] at the wound, as if to ask everyone looking at the sculpture how humanity could ever have allowed this protracted war to occur. At the same time, however, the open hand also seems capable of blessing. In this respect, despite the figure's bleakness, it still holds out the possibility of redemption.

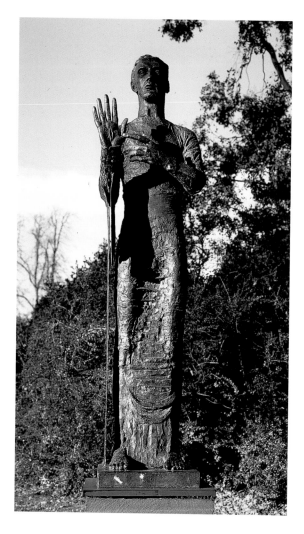

34 *Risen Christ*
1917–19
Bronze
h.218.5 (86)
Scottish National
Gallery of Modern
Art, Edinburgh

3

BETWEEN THE WARS

Like many artists of his generation, Epstein had difficulty in recovering from the desolation of war. The experimental vitality of pre-1914 London had disappeared, to be replaced by a drive to re-examine tradition that affected former members of the avant-garde across Europe. Epstein, who had always reserved the right to model in a figurative way, was undoubtedly caught up in the new mood. He had, after all, told his patron John Quinn in 1917 that 'my own essays into abstract art have always been natural and not forced. I make no formula, and only when I see something to be done in abstract form that better conveys my meaning than natural form then I use it. There is a solidity in natural forms though that will always attract a sculptor, and great work can be done on a natural basis.'[1]

But he soon found that his guard could not be dropped during the inter-war period. The attacks on his sculpture were just as venomous and abusive as before. Often laced with anti-semitism and xenophobia, they even erupted when *Risen Christ* was exhibited in 1920. Father Bernard Vaughan, indulging in an especially gruesome outpouring of racist bile, professed himself 'ready to cry out with indignation that in this Christian

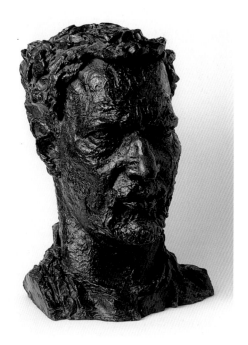

35 *Self-Portrait with a Beard*
1920
Bronze
h.38.1 (15)
City of Nottingham Museums

England there should be exhibited the figure of a Christ which suggested to me some degraded Chaldean or African, which wore the appearance of an Asiatic-American or Hun-Jew, which reminded me of some emaciated Hindu, or a badly grown Egyptian swathed in the cerements of the grave'.[2] However much Epstein tried to dismiss such hysteria, he remained vulnerable to attack from the most conservative and intolerant members of the establishment. Although he became a naturalised British citizen, and later accepted a knighthood, he always felt marginalised by his adopted country. And in his *Self-Portrait with a Beard* (fig. 35), modelled in the same year as Father Vaughan's vitriolic assault on *Risen Christ*, the fissured surface of the bronze head disclosed that the nervous exhaustion of 1918 had not yet left him.

Perhaps the turbulent psychological legacy of war helps to explain why Epstein neglected his carving for so long. After the completion of the second *Venus* in 1917, six years passed before he finally executed a pair of *Marble Arms*. Their unremarkable anatomical fidelity suggests a desire to 'return to order' after the innovative carving of the pre-war period. But any suspicion that Epstein had degenerated into timidity was confounded soon afterwards, when he accepted a commission for a memorial to the writer W.H. Hudson in Hyde Park. His first response, a clay maquette subsequently cast in bronze, was a tepid and dutiful affair. Hudson is seen reclining in a landscape with awkward limbs. The relief was mercifully abandoned once the memorial committee found out that portraiture was not permitted in the Royal Parks. The revised decision to concentrate on Rima, the nature-spirit heroine of Hudson's *Green Mansions*, transformed Epstein's attitude to the entire project. His imagination was ignited at last.

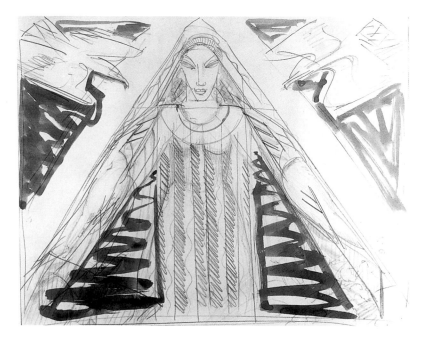

36 *Study for Rima, Memorial to W.H. Hudson*, 1923
Pencil and water-colour on paper
45.1 × 58.7
(17¼ × 23)
Leeds City Art Galleries

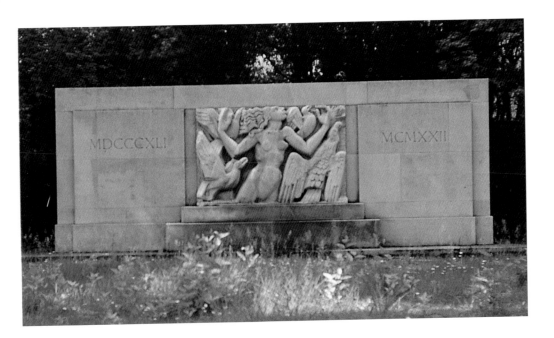

37 *Rima, Memorial to W.H. Hudson* 1923–5 Portland stone relief area 116 × 183 (45¼ × 72) Hyde Park, London

He submitted a clay model of Rima springing from the trees, with birds in flight above her. No record remains of the maquette he produced, but the Office of Works rejected it for fear that 'the sculptured stone would evoke wide and bitter controversy'.[3]

Although the prediction proved all too accurate, Epstein was not disheartened. He set to work on a sequence of large drawings in pencil and watercolour, envisioning images with a tough vitality reminiscent of his preparatory studies for *Rock Drill*. In some, Rima takes on a fearsome presence in hieratic robes, showing how keenly Epstein responded to the idea of a powerful nature goddess (fig. 36). In the final carving, though, she is naked and far more openly sensual, with long corrugated tendrils of hair electrified by her irrepressible energy (fig. 37). The carving undoubtedly gained from Epstein's decision to execute it in an isolated shed in Epping Forest. The remoteness of the setting, intensified by the 'silent and often fog-laden'[4] atmosphere of winter, was akin to the solitary setting he had cherished at Pett Level. It enabled him to approach once again the kind of concentrated intensity that produced the flenite, dove and venus carvings.

The handling of Rima's body is, however, far removed from the almost Cycladic simplification of the second *Venus*. This ecstatic nature-spirit is the very opposite of aloof. Her outflung arms are exultant, and instead of resting her weight on copulating doves she embraces the forest birds. Their wings brush against her hands, elbows and thigh. She savours an ardent rapport with her companions, and they respond with equal fervency. A debt to *The Ludovisi Throne* can be discerned in the planar organisation of Epstein's relief, and to that extent it constitutes a return on his part to Greco-Roman sculpture. At the same time, though, its unbridled rhythms break from the Hellenistic tradition. Rima's wildness discloses

Epstein's continuing involvement with non-classical sources, and he would continue to explore them for the rest of his life.

When it was unveiled in May 1925, embellished with Gill's carved inscription on the stone and set back from a poolside designed by Charles Holden's colleague Lionel Pearson, the *Hudson Memorial* excited virulent condemnation. The *Morning Post* published a petition demanding its removal, signed by the President of the Royal Academy, Hilaire Belloc, Sir Arthur Conan Doyle, Alfred Munnings and many other apoplectic members of the establishment. It was only saved by a counter-attack letter in *The Times* from, among others, George Bernard Shaw, Sibyl Thorndike and fellow sculptors like the young Frank Dobson who owed an incalculable debt to Epstein's pre-war work.[5] Their decisive intervention did not, however, prevent the carving from being branded 'The Hyde Park Atrocity' by the *Daily Mail*,[6] and smeared with green paint by a gang of protestors.

By this time, Epstein might have been excused for imagining that everything he produced was bound to excite ridicule and hatred. Even his portrait busts, executed in the more naturalistic style he preferred for modelled work, often met with disfavour. The bust of Joseph Conrad, the result of intense sessions at the writer's house, is outstanding (fig.38). The two men shared Polish ancestry, and Conrad was generous in the amount of time he devoted to the sittings. But Epstein soon realised that his elderly

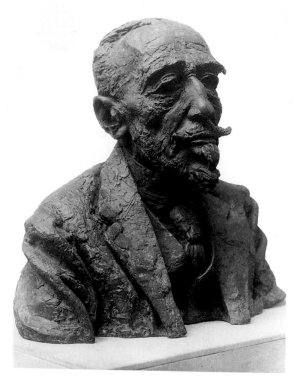

38 *Joseph Conrad*
1924
Bronze
48.2 (19)
Manchester City
Art Gallery

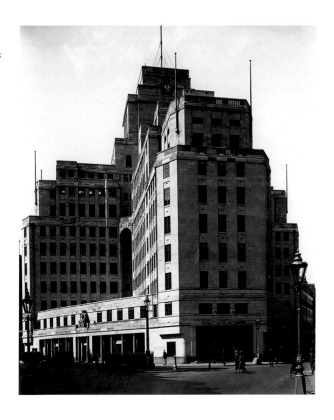

39 London Underground Electric Railways Headquarters, Westminster. Designed by Charles Holden 1928. Epstein's *Day* is visible above the entrance on the left.

subject was 'crippled with rheumatism, crotchety, nervous, and ill. He said to me, "I am finished."'[7] In the broken, pitted surface of Conrad's face, Epstein had no hesitation in conveying the full extent of the novelist's melancholy. His flesh, particularly beneath the drooping eyes, is harshly scored. The vicissitudes of his arduous life are etched in every furrow, and yet there is a tenacious pride in Conrad's bearing. Despite advancing infirmity, which killed him only five months after the bust's completion, his neck surges out of a rigid collar with obstinacy. He admired the sculpture; but the Polish government, who had commissioned the portrait, refused to purchase it. And when Epstein's friend Muirhead Bone offered a cast to the National Portrait Gallery, it was turned down.

In such a philistine context, the continuing support and patronage of his old ally Holden was invaluable. When the London Underground Electric Railways invited the latter to design its new headquarters in Westminster, he ensured that Epstein's work occupied the two most prominent positions on the building (fig.39). It was, for the most part, a severe composition of unadorned masses. But Holden's obstinate belief in the alliance of architecture and sculpture led him to commission Eric Gill, the young Henry Moore and four other sculptors to carve figures of the four winds in lofty positions. Above the entrances to the Underground Station, though, Epstein was granted far more conspicuous settings for *Day* and *Night* (figs.40, 41). They inhabit their throne-like locations with ample certitude. The constricted

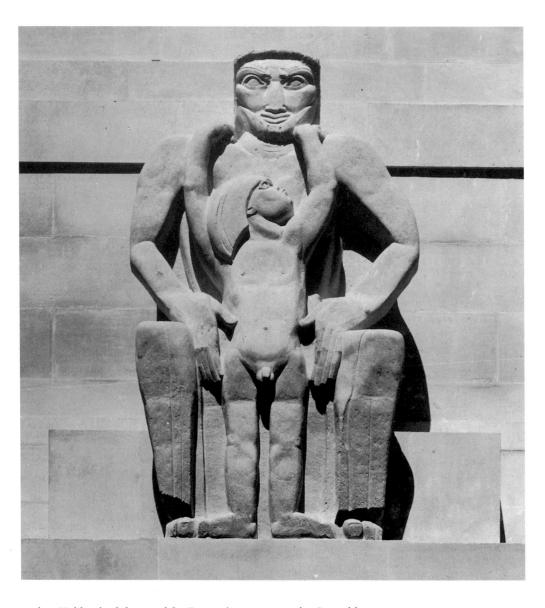

niches Holden had designed for Epstein's statues on the Strand have given way, here, to a sense of expansiveness. In tune with the gauntness of the building, both *Night* and *Day* are stripped of all unnecessary complexity. Unlike the British Medical Association figures, they were executed without the aid of full-size modelled versions. Holden himself insisted that all the sculpture for the new headquarters was 'to be carved direct in the stone without the use of the pointer or any mechanical means of reproduction', in order to 'preserve all the virility and adventure brought into play with every cut of the chisel, even at the expense of some accuracy of form'.[8]

The satisfaction derived from carrying out such a congenial task sustained Epstein during the bitter winter of 1928, working on scaffolding inadequately protected from cold and wind. This rigorous ordeal may have

40 *Day* 1928–9
Portland stone
275 × 275 × 100
($108\frac{1}{4}$ × $108\frac{1}{4}$ × $39\frac{1}{2}$)
London
Underground
Electric Railways
Headquarters,
Westminster

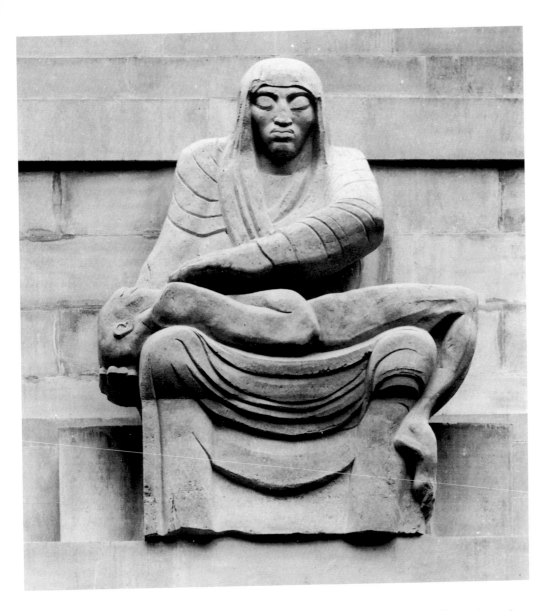

41 *Night* 1928–9
Portland stone
275 × 275 × 100
(108¼ × 108¼ × 39½)
London
Underground
Electric Railways
Headquarters,
Westminster

driven him to accentuate the sternness of his carvings. *Day* returns to a subject explored on a monumental scale by the granite *Mother and Child* over a decade before. The boy now looks upwards, however, and the parent looming above him has become a father. Reminiscent of Assyrian, Egyptian and Mexican sources, the latter appears at once protective and implacable. The son stretches both arms towards his neck, as though seeking support. But the man stares resolutely ahead, even if both hands seem ready to protect his offspring.

A similar ambiguity informs *Night*, where the equally determined mother lays to rest the 'child-man' stretched across her lap. Is she sending him to sleep, or officiating at his death? Epstein's bronze study for *Night* took the form of a *pietà*, and the carving does have a pronounced elegiac

character. A hint of sacrifice is detectable in both the Underground sculptures, but they are defensive as well. Epstein's fondness for symbolic meaning does not lead him into over-elaboration. Their formal grandeur is unimpaired, and they remain today the most assured architectural sculpture he ever produced.

The furore they ignited after their unveiling in the summer of 1929 was as vicious as ever. Vandals hurled tar and feathers at *Night*, and the *Daily Express* accused Epstein of creating a 'blood-sodden cannibal intoning a horrid ritual over a dead victim'.[9] The interpretations were so preposterous that it might have proved possible to laugh at them. At least one critic, R.H. Wilenski, made amends by claiming in the *Evening Standard* that the carvings were the 'best things Epstein has yet done'.[10] Even so, the sculptor was undoubtedly damaged by the press's ruthless persistence in arraigning him as the perpetrator of obscenities in stone. He should have received further commissions from major architects during the inter-

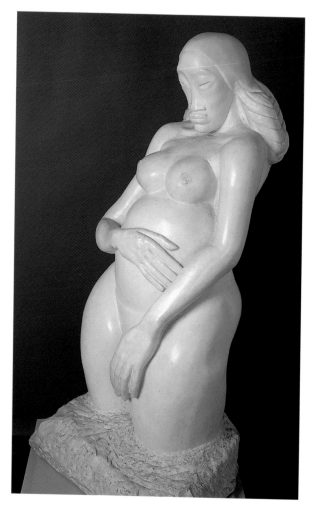

42 *Genesis*
1929–30
Seravezza marble
h.158.1 (62¼)
Granada
Television Ltd,
on loan to
Whitworth Art
Gallery,
University of
Manchester

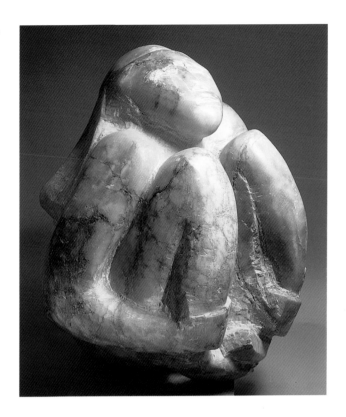

43 *Elemental*,
1932
Alabaster
h.81 (32)
Private
Collection

war period, and Holden wanted him to produce monumental carvings for the facade of London University's new Senate House building.[11] He was forbidden to employ such a heretical artist, however. Epstein had to wait twenty years before he again received a public commission of any kind.

Such neglect amounted to a national disgrace. The wonder is that he did not become disheartened, both by the widespread hatred and the reluctance to purchase his largest, most ambitious carvings. Soon after completing the Underground Railways venture, he started work on a tall marble figure called *Genesis* (fig.42). It proceeded well, aided by a clear idea on Epstein's part and sympathetic material. But the contrast between the highly African stylisation of the woman's features, and the more naturalistic treatment of her pregnant body, seems ill-judged. It lacks unity, and fails to fuse disparate sources as convincingly as *Night* and *Day*. Even so, Epstein still deserves to be respected for his courage in tackling such a theme. He must have known that this swollen celebration of fertility would affront his opponents, and a *Daily Express* headline duly rewarded him by denouncing the 'Mongolian Moron That Is Obscene'.[12]

He arrived at a more impressive level of formal integration in 1932, when *Elemental* was hewn from a lump of alabaster (fig.43). Unlike *Genesis*, this crouching figure stays close to the identity of the original block. He seems to have been caught in the process of emergence. Straining to break free from the restrictions of the material, he appears at the same time

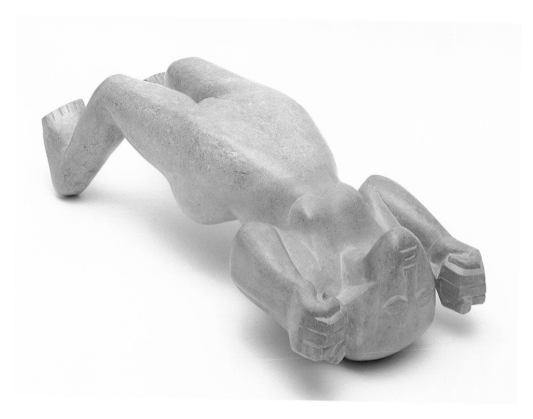

unwilling to relinquish a defensive position. His flattened face looks up apprehensively, as if in expectation of danger. Fear obliges him to stay hunched, and the lack of definition in his lower limbs suggests that movement might be difficult. So he continues squatting, and gains sculptural conviction from his body's primordial power. Never again would Epstein leave a carving as rough as *Elemental*. It remains his most raw demonstration of a desire to retain the vigour of the unchiselled stone, and the work's title suggests a striving for the simplest, most complete fusion of material and image. The figure appears to be gripped by a galvanic emotion.

This convulsive state of mind becomes even more overt in *Woman Possessed* (fig.44). Flung back on her head, the arched figure stiffens and clenches both her hands in response to an overwhelming experience. Whether terror or ecstasy is her principal emotion, she is absolutely in its thrall. Perhaps Epstein wanted to convey the intense feeling he found in African art and, above all, in a great standing figure from the Gabon River. He purchased this superb carving at the sale of the De Miré collection in the same year that *Woman Possessed* was executed. Believing that it 'equals anything that has come out of Africa', he declared that it had 'the astounding attitude of being spellbound by sorcery'.[13] So does *Woman Possessed*. Although in the act of falling, she appears curiously frozen. Stillness rather than excitability is paramount, just as it is in the De

44 *Woman Possessed* 1932 Hoptonwood stone 33.3 × 102.2 × 45.1 ($13 × 40\frac{1}{4} × 17\frac{3}{4}$) National Gallery of Australia, Canberra

Miré figure. But African influence does not pervade Epstein's carving. It is primarily his own invention, and demonstrates a continuity of interest extending back at least as far as the 1913 *Flenite Relief*, where the mother was arrested in a similar position (fig.16).

By this time, Epstein's work as a carver could be seen as a vital precedent for a fresh generation of British sculptors. Barbara Hepworth's 1927 marble *Doves* carving owes such a clear debt to his pre-war work that it amounts to an outright act of homage. As for Henry Moore, he benefited directly from the older man's example, friendship and patronage. For a while, Epstein established a paternal relationship with Moore. Impressed by the young sculptor's carvings in the early 1920s, he frequently invited Moore round to his studio, purchased several examples of his work,[14] and probably helped him gain the commission to execute a large flying figure of the *West Wind* on the Underground Railways building. Moore later recalled that, when Epstein first encouraged him, 'I was unknown and he was the most famous sculptor in Britain ... He bought works of mine before ever I had an exhibition, and he showed an excitement in my work, as he did in everything else that he liked or loved, which was characteristic of the man, and which is perhaps not found as often as one might hope in the attitude of a famous artist towards his juniors.'[15] The two men, along with John Skeaping, represented British sculpture at the Venice Biennale in 1930. And when Moore held his second one-man show, at the Leicester Galleries in 1931, Epstein wrote a generous foreword to the catalogue where he claimed that, 'for the future of sculpture in England, Henry Moore is vitally important'. At that stage in his career, Moore must have regarded the tribute as a signal honour, and he later gave Epstein clear credit for having 'introduced to this country the idea of carving direct'.[16]

Two years after Moore's show, Epstein himself staged a substantial exhibition at the Leicester Galleries. Possibly realising that his reputation as a prolific modeller of portrait busts threatened to overshadow his work in stone, he included an extensive range of carvings. Early flenite and dove pieces were displayed as well as more recent figures like *Woman Possessed*. The continuity of his concerns was stressed, above all in the first public appearance of the towering *Sun God* relief, commenced in 1910 but only completed over twenty years later (fig.11).

It found no purchaser, and an autobiographical impulse surely played a part in Epstein's subsequent decision to hew an image of the martyred Christ from a colossal block of Subiaco stone. The largest carving he had tackled since the Wilde tomb in Père Lachaise, *Behold the Man* occupied Epstein intermittently for a decade (fig.45). Its emphasis on both suffering and survival directly echoed his own experiences, as the most reviled yet defiant contemporary artist in Britain. Perhaps his close identification with the battered, stubborn figure of Christ helps to explain why *Behold the Man* is the least subtle of Epstein's carvings. He might have been better advised to leave the stone in an unfinished state, as it was when first exhibited at the Leicester Galleries in 1935. On that occasion, the *Daily Telegraph*'s reviewer remarked on 'the elimination of all but the barest detail and the

broad lines on which the features of the face are indicated'.[17] When finally completed, *Behold the Man* was undermined by coarse over-statement. It appears most impressive viewed from the sides, where Epstein's rigorous adherence to the elongated cubic block is readily apparent.

His determination to honour the innate character of his material was as resolute as ever, and accounts for the compressed power of his 1936 carving *Consummatum Est* (fig.46). He often bought immense boulders of stone without any notion of how they might be used, and in this instance his respect for the alabaster led him to leave it untouched in the studio for an entire year. Knowing only that he must 'do no violence to it as stone',[18] Epstein waited until the 'Crucifixus' section of Bach's B Minor Mass finally provided the stimulus he required. The music enabled him to 'see immediately the upturned hands, with the wounds in the feet, stark, crude, with the stigmata'.[19]

After the obstinate verticality of *Behold the Man*, the horizontal repose of *Consummatum Est* seems cathartic. With its echoes of Egyptian funerary art and an Assyrian beard, the figure is utterly resolved. But the meaning of the title, translatable in English as *It Is Finished*, does not match the sculpture's sense of residual strength. The head is still raised, as though resisting extinction, and the thrusting feet are obtrusive enough to suggest

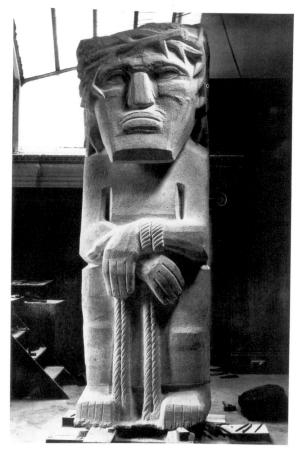

45 Studio photograph of *Behold the Man (Ecce Homo)*, 1934–5 Subiaco stone h.300 (118) Coventry Cathedral, ruins

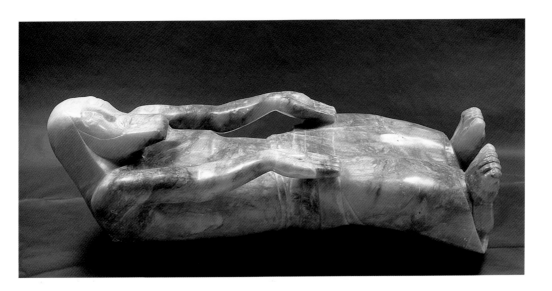

46 *Consummatum
Est* 1936
Alabaster
61 × 223.5 × 81.3
(24 × 88 × 32)
Scottish National
Gallery of Modern
Art, Edinburgh

latent energy. His hands may not be as demonstrative as in the openly
accusatory *Risen Christ*, who had pointed at his gashed palm in the after-
math of the Great War (fig. 34), but they are still displayed with delibera-
tion. If death is the theme here, Epstein insists on exploring it with a
characteristic sense of resilience.

He had every reason to feel morose, however. In 1937, the same year
that *Consummatum Est* was first exhibited at the Leicester Galleries, his
British Medical Association statues came under renewed onslaught.
Holden's building had acquired a new owner, the Government of Southern
Rhodesia. It maintained that the carvings were decayed enough to
threaten the safety of passers-by below. Once again, Epstein's admirers
mounted a campaign to save the figures, fortified by the knowledge that
they had recently staged a successful defence. The High Commissioner of
Southern Rhodesia had announced, just after taking over the headquarters
in 1935, that the carvings 'are not perhaps within the austerity usually
appertaining to Government buildings'.[20] This pompous bureaucratic
language masked prudish disapproval, along with a determination to
eradicate Epstein's embarrassing display of nudity. When the President
of the Royal Academy, Sir William Llewellyn, loftily refused to sign a letter
of protest on the grounds that it was 'not an Academy affair',[21] Walter
Sickert resigned. By the summer of 1935, the statues' future seemed to be
assured.

But when the issue of public safety was raised two years later, Epstein's
defenders were unable to protect his work any longer. After the removal of
decorations hung on the figures for George VI's coronation procession, a
piece of stone fell onto the pavement and bruised a pedestrian's foot.
The London County Council issued an injunction to make the sculpture
safe. And the Southern Rhodesian Government was delighted to oblige,
even refusing Epstein's plea to oversee the restoration of his statues. Only
Holden was permitted to join the group, ironically including the President

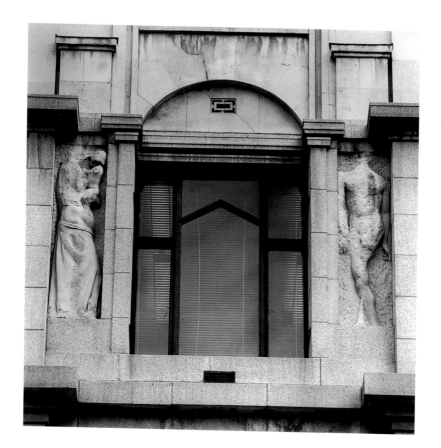

47 Mutilated figures of *Maternity* (left) and *Man* (right) on the former British Medical Association Building, Agar Street, London

of the Royal Academy, who mounted the scaffolding and inspected the figures, one by one. Anything deemed unstable was duly chiselled away, irrespective of its sculptural significance (fig.47). Holden later attempted to make light of the vandalism, asserting that 'the general decorative character of the band of figures was not seriously destroyed, and they still convey something of Epstein's intention to portray the "seven ages of man"'.[22] But the melancholy truth is that heads, limbs and symbolic attributes were among the victims, reducing Epstein's work to ruin. He made a far more accurate assessment of the wreckage when describing how 'anyone passing along the Strand can now see, as on some antique building, a few mutilated fragments of my decoration'.[23]

Henry Moore was so appalled by the Royal Academy's participation in this disgraceful affair that, even late in life, he still vehemently insisted that 'I'll never forgive them ... That's why I'll never exhibit in the Academy.'[24] Epstein, however, refused to remain dejected about the desecration for long. He started work the following year on a carving grand and ebullient enough to constitute a mighty act of defiance (fig.48). On one level, *Adam* can be seen as a demonstration of Epstein's refusal to let his spirit be broken, either by the BMA tragedy or any of the other rebuffs he endured. This naked titan is indomitable, and he surges upwards from the rough-hewn alabaster base like a man rejoicing in his own primal vigour. On another

level, the form assumed by the figure is a direct response, on Epstein's part, to a block that had lain in his studio even longer than the alabaster he used for *Consummatum Est*.

Once he had decided on the execution of *Adam*, though, the carving was completed within a year. Unlike *Behold the Man* (fig.45), it did not linger in an unfinished state for a decade. The swiftness of execution helps to explain why *Adam* is a more convincing sculpture than his earlier attempt at a Man of Sorrows. 'The conception, fairly clear in my mind in its general outlines, developed a law of its own as it proceeded', he wrote, 'and I managed to get a tremendous movement within the compass of a not very wide, upright stone.'[25] Epstein thrived on the challenge of finding such vitality inside the constraints presented by the alabaster. They forced him to restrict the figure's gestures, so that *Adam*'s jutting arms are pressed tightly to his sides rather than flung outwards. Melodrama is thereby avoided, even as the integrity of the block is respected. But the figure is not static. His right leg is about to step forward, and his brazenly exposed genitals likewise seem to be on the move.

In its exuberant celebration of male energy, *Adam* can be seen as the culminating expression of a subject Epstein had first tackled in *Man* at the BMA headquarters. If the unbridled sensuality of Whitman's poetry had played a germinal role in the Strand statues, it became even more overt when *Adam* was carved. In *I Sing The Body Electric*, an ecstatic hymn to corporeal magnificence, Whitman declares:

If any thing is sacred the human body is sacred,
And the glory and sweat of a man is a token of manhood
 untainted

This impassioned affirmation is followed by a close scrutiny of the masculine physique, journeying from head to feet with amorous intensity. Epstein did not share the poet's homoerotic impulse. But he had illustrated Whitman's *Calamus* in 1902, and admired his readiness to extol each part of the body without embarrassment:

Hips, hip-sockets, hip-strength, inward and outward round,
man-balls, man-root,
Strong set of thighs, well carrying the trunk above[26]

The words could easily be applied to *Adam*, the work of a sculptor who had once shared Whitman's nationality and wanted, more than ever before, to combat his adopted country's disapproval of nakedness and sexual energy in art. As early as 1908 he had deplored the fact that 'today the use of great words like "virility" has become so smirched by coarse shame that it becomes a hazardous thing for an artist to use them in his work'.[27] But he was always prepared to risk opprobrium, even when the directors of his own gallery tried to prevent him from exhibiting *Adam* for the first time in 1939. When Epstein showed them the carving, 'they said nothing and left my studio. The next day they wrote to me saying that they could not see their way to showing the statue. I was astounded, and did not try to

persuade them.' But Epstein stood his ground, telling the Leicester Galleries that he would not be prepared to withdraw *Adam* and exhibit his portrait bronzes alone. 'Thereupon the Directors paid another visit to my studio, finally to make up their minds. I left them alone with "Adam" for three hours, after which, with many qualms and forebodings, they agreed to show the carving.'[28]

The sculpture's towering size made it unavoidable in the exhibition, permitting no one to overlook the prominence and generous proportions of the genitals. Writing in *Picture Post*, the Scottish artist William McCance described an incident he had witnessed in the gallery where *Adam* was displayed: 'A charming old lady came forward into the room, and, with a supercilious air, raised her lorgnette to look at the sculpture. In another moment the lorgnette seemed to be swept clean out of her hand and with it went all the haughtiness and supercilious gesture. She hurried away ... there was no doubt that she had been deeply horrified.'[29]

There is, all the same, a profound ambiguity informing *Adam*. The head is thrown back, in order to gaze upwards. But does he stare at the sky with unalloyed pride, or fear? His open hands could be interpreted as beseeching, the gesture of a man who knows he has sinned and implores forgiveness. The titan's forward step might even suggest that he is being banished from Eden. Epstein was certainly meditating on the biblical notion of The Fall in 1938, a year when Europe was already disrupted by upheavals fore-shadowing the cataclysm to come. His small bronze called *Adam and Eve* concentrates on the moment when the disgraced pair recoil from God's wrath, and the shocked, etiolated bodies leave no room for doubt about their plight. The carved *Adam*, by contrast, remains formidable in his sturdiness. His sense of well-being is paramount, and guilt has not yet tempered his pride to a significant extent. But tension can certainly be detected in the violent jerk of his head, giving the sculpture more than a hint of the melancholy Epstein would develop in his next major carving.

This time, he did not have to wait long for a buyer. *Adam* was purchased for £750 by Charles Stafford, the director of a gold-mining business. Any pleasure Epstein may have derived from the sale was, however, short-lived. For Stafford made an enormous profit by selling the exhibition rights to Lawrence Wright, who had no qualms about displaying the carving in a Blackpool funfair. Visitors were charged a shilling a visit to gape at *Adam*. Epstein was mortified when he heard that his work had been reduced to the level of a pornographic amusement. 'I would have liked it to be shown at the Tate Gallery', he complained, 'but you know it would have been rejected – the trustees of the Tate are lacking in both imagination and initiative.'[30] The accusation was justified: although Epstein had by now been working in stone for over thirty years, most of the time in England, the Tate failed to acquire a single carving. The error was only rectified long after Epstein's death,[31] but he refused to be disheartened by official neglect. Not even the advent of another world war prevented him from embarking, a few months after hostilities commenced, on the grandest and most turbulent of all his carved work.

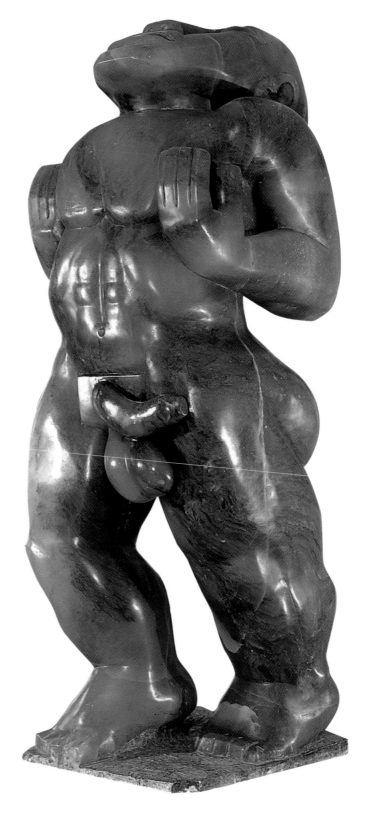

48 *Adam* 1938–9
Alabaster
218.5 × 66 × 81.3
(86 × 26 × 32)
Harewood House,
Yorkshire

4

THE FINAL YEARS

The declaration of hostilities against Hitler revived in Epstein's mind the traumatic devastation inflicted by its predecessor. 'This war is terrible', he wrote in September 1939, 'and will settle nothing. When millions have been killed and wounded the world will be as bad as ever, and we are going to be plunged back into a common barbarism in the meantime.'[1] The likelihood of commissions for public sculpture, never strong after the scandals of the 1920s and the irreversible damage suffered by the Strand statues in 1937, became wholly remote during the war years. Even the requests for portrait bronzes dwindled, and Epstein found himself in danger of failing to meet the expense of bronze castings and all the other overheads incurred by his prolific activity as a portraitist. For a while, he must have wondered if he could afford to retain the outstanding collection of over a thousand African, Indonesian and other so-called 'primitive' carvings largely amassed during the previous decade.[2]

No wonder Epstein's mood darkened. While the Nazi troops overran much of Europe, including his ancestral Polish homeland, he worked on his autobiography. Towards the end of the text he disclosed just how apocalyptic his expectations had now become: 'I imagine a waste world; argosies from the air have bombed the humans out of existence, and perished themselves, so that no human thing is left alive.'[3] In the face of this terrifying vision, his readiness to undertake another colossal alabaster carving was tantamount to an act of resistance. Writing about *Adam*, he confessed that 'into no other work had I merged myself so much'.[4] But those words were written before he went on to commence *Jacob and the Angel* in 1940.

In one respect, the choice of subject surely reflects his appalled response to the struggle in Europe. The story in *Genesis* of Jacob's nocturnal encounter with a mysterious man, who 'wrestled ... with him until the breaking of the day',[5] had a ready-made pertinence during this protracted conflict. But the emotional charge of the carving itself proves that Epstein had other, more personal motives for choosing the subject as well. It was surely significant that he shared his first name with the biblical Jacob. The wrestling enacted in the sculpture paralleled his own attempt to struggle with the outsize slabs of stone he favoured. For a whole year his sustained and concentrated expenditure of energy on this great carving was as formidable, in its way, as Jacob's valiant attempt to fight his anonymous

49 *Jacob and the Angel* 1940–1, Alabaster 213 × 109 × 117 (84 × 43 × 46) Tate Gallery, London

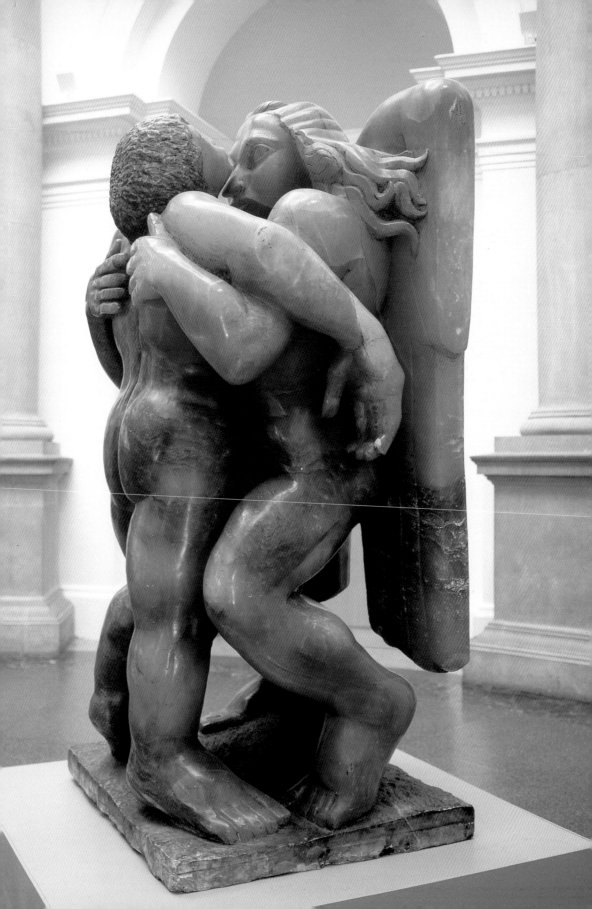

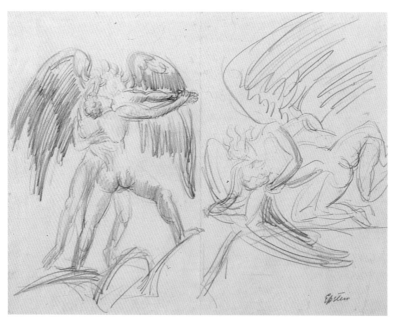

50 *Two Studies for
'Jacob and the Angel'*
1939–40
Pencil on paper
43 × 56 (17 × 22)
Formerly in collection
of Granada Television
Ltd

51 *Jacob and the Angel*
(detail)

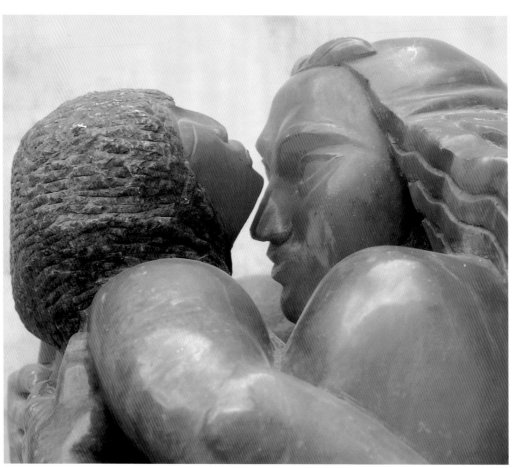

antagonist. When the angel's wings are viewed from behind, their insistent flatness retains a suggestion of the unhewn block. So Jacob could be seen as an embodiment of the sculptor himself, seeking to impose his will on the material rearing like a cliff in front of him.

The Old Testament story relates, however, that Jacob failed to vanquish his opponent. Having suffered a dislocated thigh, he was reduced to holding onto his adversary's body and refusing to let go. When Jacques Lipchitz modelled a sculpture of the same subject nearly ten years earlier, he interpreted the struggle as a sign 'that God wants us to fight with him'.[6] But Epstein's imagination was kindled by the sensuality inherent in their combat. A pair of vigorous pencil studies for his carving show Jacob and his winged opponent standing with arms outstretched in an impassioned dance, and then falling to the ground like lovers locked in a carnal embrace (fig. 50). They recall the homoerotic illustrations Epstein had made for Whitman's *Calamus* at the beginning of the century. Even if the

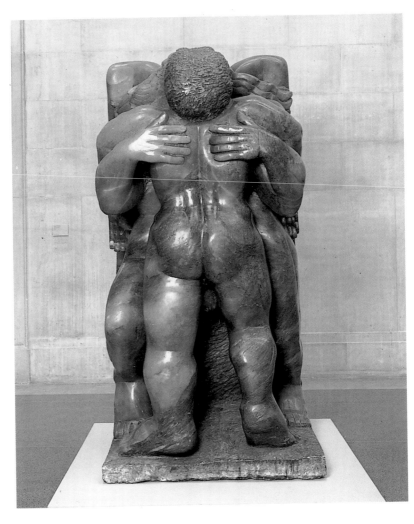

52 *Jacob and the Angel* (front view)

final alabaster is far more ambiguous about the nature of their union, aggression and love are still intertwined in its swollen forms.

Epstein elected to dramatise the latter phase of the conflict, when dawn approaches and Jacob is forced to succumb to the stranger's power. But his spirit does not appear cowed by defeat. Jacob's limp figure submits to the angel's grip with an acceptance of its inevitability. His head dropping back, in a movement reminiscent of the ecstasy experienced by *Woman Possessed*, he seems to gain unexpected fulfilment from his intimacy with an antagonist whose superlative power is far from destructive.

Assent can even be detected in his slack limbs. Like Epstein himself, who realised how much a sculptor could gain from allowing the nature of his material to play a decisive role in the carving's development, Jacob finally became enriched by his stubborn refusal to let the angel go. His opponent blessed him and, after vanishing at daybreak, left him with immeasurably enhanced strength. Perhaps Epstein saw a parallel, here, with the sculptor's capacity to benefit from the closest possible engagement with, and acknowledgement of, the profound stimulus inherent in the stone.

By this time, his respect for the material he used was limitless, and sharpened by a tender, almost protective desire to ensure that it was treated with an appropriate sense of deference. 'At the stone-yard', he wrote in his autobiography, 'I see a tremendous block of marble about to be sliced up and used for interior decoration. When I see these great monoliths lying ready for the butcher's hands, as it were, I instantly have sentimental feelings of pity that the fate of a noble block ... should be so ignominious. Knowing that this stone could contain a wonderful statue moves me to purchase it and rescue it, even though at the moment I have no definite idea for it. Never mind – that will come.'[7]

Anyone who honoured his material so deeply was bound to feel wounded when *Jacob and the Angel* ended up sharing the humiliation meted out to previous carvings. It was bought by William Cartmell, and installed in the basement 'anatomical department' of Louis Tussaud's Blackpool showroom where *Adam* and *Consummatum Est* were already on display. Here, in garishly decorated seafront premises advertised by 'a loudspeaker blaring swing tunes and a dozen marionettes dancing on strings', a recorded barker summoned passers-by to gawp at 'the strangest thing you have ever seen'. Inside, the carvings were 'surrounded by human heads shrunk to the size of apples by Indian head-hunters, moving marionettes and the embalmed body of Siamese twins'.[8] Epstein, who

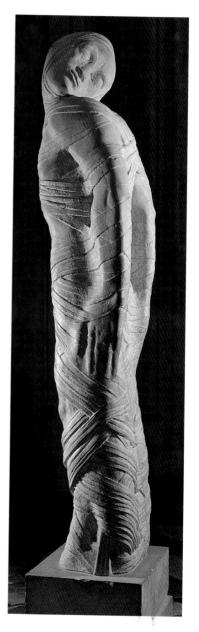

53 *Lazarus* 1947–8
Hoptonwood stone
h.254 (100)
By permission of the
Warden and Fellows,
New College, Oxford

longed to find more dignified locations for his work, tried to be stoical. But the fact that six years elapsed before he again tackled a carving may indicate how offended he really felt. After *Jacob and the Angel*, he never used alabaster again. Indeed, he only completed two more carvings during the rest of his productive career. Although advancing age may have helped to account for his unwillingness to handle large stones, he must also have been affected by the melancholy realisation that each of his most ambitious carved works had found itself 'in a world where it is not wanted'.[9]

When he next embarked on a carving, it was significantly removed in mood from *Adam* or *Jacob and the Angel*. His misgivings about the likely reception of the sculpture, combined with the shock of his wife's recent death after a fall, conspired to make him produce the gravest and least demonstrative of all his large-scale works. But the fact that he commenced *Lazarus* in 1947, when a long and debilitating war had only just come to an end, was probably the most significant factor informing his choice of subject. Just as he had produced *Risen Christ* after the First World War (fig. 34), so he now imagined another figure emerging from the tomb. But there is nothing triumphal about *Lazarus*'s awakening. Far more embroiled in the stillness of death than *Risen Christ*, he seems almost reluctant to release himself from the thick bands bound so tightly around his body. His eyes remain closed; and although his head is turned, as if searching for the light, it rests on his shoulder in apparent exhaustion (figs. 53, 54).

Britain was likewise afflicted by weariness in the aftermath of war. Victory over Hitler and Japan did not lead to immediate resurgence. Too many lives had been lost, and the nation's economic resources were severely depleted. Austerity prevailed in 1947, when the country emerged from an unusually severe and prolonged winter with the growing realisation that genuine recovery was only a remote hope. In this respect, *Lazarus* offered an authentic reflection of the national mood. Executed in pale Hoptonwood stone rather than warm, richly veined alabaster, the reviving figure lacks the robust physique of his immediate carved predecessors. His arms may have begun to raise themselves in obedient response to Christ's command, but they still seem inhibited by the bands encircling them. Despite the size and solidity of the tall stone figure, he appears spectral. The battle between death and life is still being waged within his body, and frailty remains its overriding characteristic.

Now in his late sixties, Epstein was prepared to convey a far greater apprehension of human vulnerability than his earlier carvings had admitted. *Lazarus* is also one of his most restrained works, lacking the bombast that often mars his late bronze figures. Subtle, tender and compassionate, it won over many viewers at his Leicester Galleries exhibition in 1950. Wyndham Lewis, who had responded so positively to *Rock Drill* in 1915, declared that *Lazarus* was 'perhaps the most impressive of his series of giant carvings'. Lewis particularly admired the expression of helplessness: 'this face rolled back upon a shoulder, the rest of the body still numb, as it stands tied up for the last sleep, is a feat of the creative imagination.'[10]

If it had been installed in an appropriate public setting, *Lazarus* would have made a superb London memorial to the recent war. But nobody was prepared to secure it for the nation, and Eric Newton angrily asked in *The Sunday Times* why no architect had 'been daring enough to use [Epstein] as the Egyptian and the Romanesque sculptors were used, or as Donatello and Verrocchio were used to deepen the significance of a cathedral crypt, to stand mysteriously behind an altar, to form the climax of a staircase or give meaning to an empty niche? His two pieces on the Underground building and the mangled statues in the Strand are not enough. The mid-twentieth century possesses a great sculptor and forces him to dilute his genius.'[11]

The response to *Lazarus* marked a sea-change in the reception of Epstein's work. Throughout the decades he had longed for the opportunity to place his carvings in locations capable of enhancing them, not of mocking their ambitions in a seaside arcade. When working on *Consummatum Est* he had imagined 'the setting for the finished figure, dim crypt, with a subdued light on the semi-transparent alabaster'.[12] Now, at last, he found a patron who could provide just such a context. Alic Smith, the Warden of New College, Oxford, visited Epstein's studio to sit for his portrait. Admiring *Lazarus*, he realised that it would be ideal for the college's antechapel. After lengthy negotiations and partially success-ful fund-raising, Epstein decided to let them buy the figure for a modest £700. 'I have never thought of this resurrection carving as an object of commerce', he wrote to Smith in 1951, 'and if a reasonable sum has been contributed I would gladly let it go for whatever has been acquired for its purchase ... The setting up of the statue as a memorial in the chapel so appeals to me that I will do whatever I can on my part to realise this destiny.'[13] Its eventual installation in the antechapel at New College was described by the gratified sculptor as 'one of the happiest issues of my working life'.[14]

By 1951, a new post-war determination to enlarge the role of artists found spectacular expression in the Festival of Britain. Young architects were commissioned to design an adventurous, if frankly heterogeneous cluster of buildings on the south bank of the Thames. Sir Gerald Barry, the Festival's Director General, ensured that an abundance of artists provided paintings and sculpture in prominent locations throughout the site. At an early stage in the planning, he argued that 'the size of modern architec-tural projects enforces teamwork: the groups working together on them should include not only the scientist and the sociologist, but also the painter and sculptor. This might bring the artist out of his seclusion, and give him a new place in the social order.'[15]

Barry's words signalled a new willingness, on the part of those associ-ated with the post-war Labour government, to ensure that artists played a more active role beyond the confines of the studio. Epstein, having been ignored for so long by those capable of commissioning large-scale sculpture for public settings, now found himself in demand. He was caught up in the general sense of excitement generated by planning a Festival intended as an antidote to 'the national dinge'[16] of austerity-oppressed Britain. In tune

54 *Lazarus* 1947–8 (detail)
By permission of the Warden and Fellows, New College, Oxford

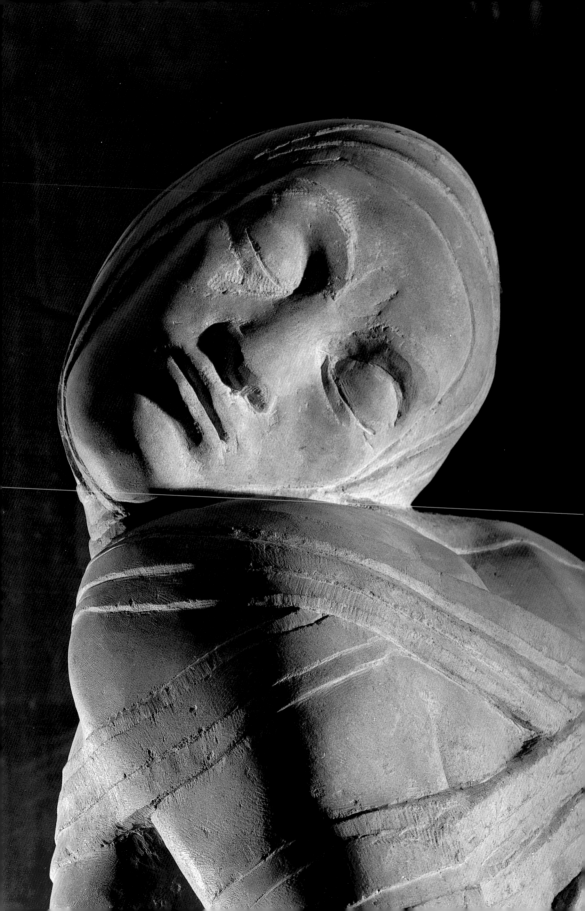

with the new mood, Epstein produced a
tall bronze called *Youth Advancing* (fig. 55).
With a typical determination to avoid
national stereotypes, he modelled the
figure on a half-Chinese boy who
also sat for a head around the same
time. The Festival sculpture cannot,
however, be counted among his most
convincing works. It seems forced and
surprisingly academic, the product
of a commission that failed to ignite
Epstein's imagination at its deepest
level.

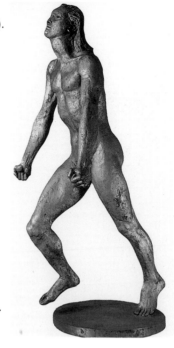

55 *Youth Advancing*
1949–50
Bronze
h.208 (82)
Manchester City Art
Gallery

Striding forward on a circular plinth
by a pool between pavilions, *Youth
Advancing* looked tame in a Festival
where other, emergent artists demon-
strated the renewed spirit of vitality and
 experiment in post-war British sculpture.
Eduardo Paolozzi's steel and concrete
Fountain, Reg Butler's welded metal
Birdcage and Lynn Chadwick's sheet metal
Cypress all announced, in their different ways, new possibilities for young
sculptors to explore. As for Henry Moore, who had once been Epstein's
protégé, he asserted a commanding presence with a bony *Reclining Figure*
opposite the Festival's main entrance. The position occupied by his etiolat-
ed yet resilient bronze woman, who lifts her split head to the sky with an
unease still redolent of wartime anxiety, signified Moore's pre-eminent
position in contemporary British art. Far more favoured than Epstein
by influential critics like Kenneth Clark and Herbert Read, he was also
beginning to gain formidable international acclaim. Epstein, by contrast,
had failed to furnish himself with a substantial reputation outside
Britain.

Even in his native America he was not as widely appreciated as he might
have wished. In 1928 he had held an exhibition of his bronzes at Ferargil's
in New York, and appeared as a defence witness in a notorious Manhattan
court case held to determine whether a Brancusi *Bird* sculpture was a
legitimate work of art. Epstein might have imagined that he enjoyed a
certain celebrity in the city of his birth. But as the American critic Henry
McBride wryly pointed out, the court proceedings merely illustrated 'what
he is up against in his return to America after twenty-five years of
burial in England ... neither this judge nor that lawyer ever seemed to
have heard of Mr Epstein before!'[17] Eventually, in 1951, he was invited to
produce a group of bronze figures called *Social Consciousness* for an ambi-
tious Memorial in Philadelphia, intended to be 'emblematical of the history
of America'.[18] But the outcome, a seated mother flanked by two pairs of
interlinked figures symbolising consolation and maternal support, did

little to boost his stature in an American art world now understandably preoccupied with the efflorescence of its own, home-grown avant-garde.

In England, where he was finally granted a Tate Gallery retrospective in 1952, his major post-war commissions were greeted with more enthusiasm than his earlier public sculpture. The most generally admired was a monumental *Madonna and Child*, made in lead for the north side of Cavendish Square in London (fig. 56). The site was unconventional: a stone bridge linking two older, Palladian buildings inhabited by the Convent of the Holy Child of Jesus. The architect, Louis Osman, realised that the plain supporting wall above the bridge's arch would provide a discreet backdrop for sculpture. Far from contenting himself with a token work in low relief, he decided that a fully modelled piece with a powerful identity was preferable. 'One cannot just apply a great work of art to a building and expect a happy marriage', he wrote afterwards. 'If the sculpture is important it must be given its head, like the role of a soloist in a concerto; the orchestra being like the architecture, with the solo instrument speaking its poetry; related but clear and independent.'[19]

Epstein did not disappoint him. Appreciating that Osman had provided him with a chance few contemporary architects were prepared to match, he produced the most successful of his large modelled sculptures. The

56 *Madonna and Child* 1950–2
Lead
h. 390 (153½)
Former Convent of the Holy Child of Jesus, Cavendish Square, London

Madonna, whose face is based on his pianist friend Marcella Barzetti, looks down solemnly in the direction of her son. The meditative restraint of her expression, which makes such a decisive contribution to the intensity of the work as a whole, is a measure of Epstein's willingness to respond to his clients' wishes. For the nuns of the convent, intially dismayed by their architect's choice of such a notorious sculptor, only accepted Epstein when Osman threatened to resign. The Mother Superior visited the sculptor's studio and, after examining the plaster version, asked him to give the Madonna a more contemplative face. Epstein complied, thereby increasing the dignity of the sculpture and making the Madonna a more effective foil for the outward-facing child. He extends his arms in a pose Epstein must surely have intended as ambiguous, conveying a desire to embrace even as it foreshadows his suffering on the cross. He is a vulnerable figure, and the bands swathing his attenuated limbs recall the death-in-life tension of *Lazarus*. But he possesses an innate poise as well, and the steadfastness of the boy's open gaze discloses a maturity far beyond his years.

Whatever Epstein's private reservations may have been about the quality of the architectural projects to which he contributed, he rarely turned them down. Unlike Moore, who always harboured instinctive fears about the subservience of sculpture in modern buildings, Epstein was ready to take the risk. Sometimes, the gamble paid off. Although unremarkable in itself, Osman's bridge provided a relatively neutral back-drop for the *Madonna and Child*. On other occasions, however, Epstein became involved in more questionable ventures. Accepting a commission for the facade of a nondescript new Lewis's store in central Liverpool, he produced a thoroughly unconvincing bronze colossus called *Liverpool Resurgent*. The three panels below, especially the boisterous *Children Fighting*, have far more vivacity than the ponderous titan perched, with his curiously flailing arms, on the prow-like plinth.

His response to Llandaff Cathedral, damaged during the Second World War and then under reconstruction, was more impressive. But he admitted to a justifiable dislike[20] of the reinforced concrete arch designed by the architect, George Pace. Spanning the gothic nave, in place of a traditional pulpitum dividing the choir from the main body of the cathedral, the arch looked anomalous. However much unforced dignity Epstein gave his aluminium *Christ in Majesty* on the cylindrical organ loft above, with simple gestures echoing the Cavendish Square Madonna, the figure's potential impact is undermined by Pace's design (fig. 57). Christ is handled with commendable restraint, by a sculptor who managed to curb his bom-bastic leanings and opt instead for severity. But the strength of this gaunt, beneficent presence is diluted by the fussiness of the flanking structures on the organ case, where Pace installed the gilded statues that had embellished the Chapter stalls before the Cathedral was damaged by enemy action in 1941. Even if the intriguing plan had been implemented to com-mission a Stanley Spencer mosaic of *The Last Judgement* for the arch's underside, it would still provide an undistinguished context for Epstein's work.

57 *Christ in Majesty*
1954–5
Aluminium
h.430 (169)
Organ loft, Llandaff
Cathedral, Wales

He was more fortunate at Coventry, where a building designed by Basil Spence to replace the city's blitzed medieval cathedral was erected on a neighbouring site. Stimulated by the proliferation of painting and sculpture at the Festival of Britain, Spence wanted his new cathedral to be a showcase for contemporary art. He approached Moore with the suggestion of carving eight large reliefs to line the nave, but the latter preferred sculpture in the round and advised him to abandon the project.[21] When Spence asked Epstein to model *Saint Michael and the Devil* for the red sandstone facade, the response was more positive. Coventry's Reconstruction Committee harboured misgivings about Epstein's Jewishness, however, and questioned his suitability for such a venture. So Bishop Gorton went to examine the *Madonna and Child* in Cavendish Square. Having seen for himself how well the suspended figures suited their location, he announced: 'Epstein is the man for us.'[22]

In the freely handled maquette, the devil hides his humiliated face from a saint whose body is far more slender than in the final version. Maybe Epstein felt that the two figures were not sufficiently integrated, for he made the devil look up at the saint in the full-scale sculpture (fig. 58). But his body suffers from excessive muscular rigidity, and so does Michael's torso. Only in the saint's face, based on Epstein's son-in-law Wynne Godley, does he allow himself to explore the full ambiguity of a victor at once stern-

ly triumphant and burdened with a melancholy awareness of his own capacity for destruction. Nothing could be more appropriate for a site where the tragedy of a gutted cathedral is movingly juxtaposed with the affirmation of its successor (fig. 59).

The legacy of war also informed Epstein's final carving, a major architectural venture commissioned by the members of the Trades Union Congress. They wanted, for their new London headquarters in Great Russell Street, a memorial to commemorate the trades unionists who had been killed in both world wars. Bernard Meadows, a leading member of the new generation of British sculptors, had produced a curiously academic bronze group for the exterior of the building. Sylistically at odds with his other work, it indicated that Meadows had felt inhibited by the symbolic demands of the subject. Epstein, however, found the TUC's invitation to produce a sculpture for the internal courtyard immensely congenial. He had, after all, wanted to make an official memorial after the Great War, producing *Risen Christ* on his own initiative when the opportunity for a public commission failed to materialise (fig. 34). Thirty years later, on the eve of another world war, he declared that 'I should like to remodel this "Christ." I should like to make it hundreds of feet high, and set it up on some high place where all could see it, and where it would give out its warning, its mighty symbolic warning to all lands. The Jew – the Galilean

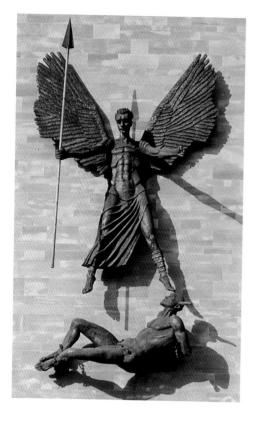

58 *St Michael and the Devil*
1956–8
Bronze
h. 1,066 (419)
Coventry Cathedral

59 View of Coventry
Cathedral with *St Michael and the Devil*

– condemns our wars, and warns us that "Shalom, Shalom", must be still the watchword between man and man.'[23]

Now, in March 1955, he was at last granted the chance to carve a summation of his views on war. Having refused to participate in a competition for the TUC memorial the previous year, he was delighted to accept a direct invitation with the promise that 'complete freedom is given in the conception'[24] of the work. The assurance was invaluable, especially to a seasoned seventy-five year-old artist with half a century's experience of ferociously divisive public commissions behind him. The architect of Congress House, David du R. Aberdeen, had provided him with a daunting location: a pyramidal cliff of green marble,[25] so immense that it might easily have dwarfed the sculpture marooned on a tall stone plinth at its base. Epstein, however, was not overwhelmed. He produced a maquette of a mournful woman carrying in her arms a dead soldier with a clearly identifiable helmet on his head. The vigorously modelled group is reminiscent of the *pietà* he had used as a preliminary study for *Night* on the Underground building (fig.41). This time, though, the woman is standing, and strong enough to bear the weight of the young man's body. She looks up rather than sorrowfully down at the corpse, as if protesting his death to the heavens.

In the carving (fig.60), Epstein discarded the helmet and transformed the dead soldier into a nude. But he retained the sense of anger. By now far less robust, he departed from habit by letting assistants carry out preparatory cutting on the block of Roman stone. 'I have let myself in for some devilish hard work', he wrote to his daughter in March 1956, 'as this particular block is as hard as granite and tools just break on it.' But he was willing to persevere, working on site in a hut erected for the purpose. Although Epstein must have missed the secluded surroundings that helped him bring so many of his previous carvings to completion, he had coped with a

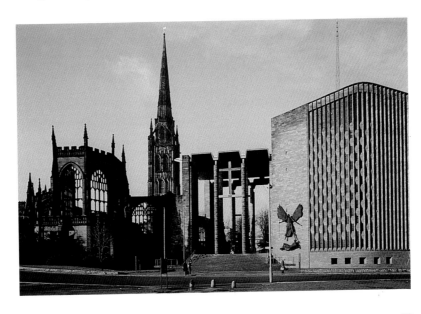

busy construction site when working on the Underground commission. 'I am making good progress', the same letter continued, 'and if it weren't for the terrific noise of building going on all about me I would feel all right.'[26]

The effort involved in finishing the sculpture was taxing, and may well have further weakened his once-formidable constitution. All the same, he was able to produce a memorial of rude power. His desire to honour the character of the stone block made him emphasise the carving's vertical thrust. The young man's corpse is no longer allowed to jut out so far from the woman's sides, as it had done in the maquette. She gathers him up more securely in her arms, refusing to let his head fall forwards. This is a mourner galvanised by an even fiercer emotion than the maquette had suggested. Her primordial face is uncompromisingly grim, and her accusatory stance has none of the genteel pathos found in so many conventional war memorials. The indignation in the TUC sculpture may have been reinforced by the bereavements Epstein himself had recently suffered. Early in 1954 his son Theo died of a heart attack at the age of twenty-nine, and later in the same year his daughter Esther committed suicide. The stricken matriarch in his carving probably reflected some of the parental grief he had experienced. It is a raw sculpture, stripped of inessentials and anything that might have threatened to distract the eye from the woman's hands clamped hard on the inert limbs, or the intensity of her implacable gaze. Epstein had been preoccupied with the image of a female figure holding a young body ever since he produced *New-Born* for the BMA headquarters fifty years before (fig.6). Now, however, the devastation of two world wars combined with his own children's loss to ensure that the *TUC War Memorial* conveyed an abrasive desolation. Epstein's respect for the austere form of the Roman stone gives the carving a blanched, almost glacial impact.

Thrombosis and pleurisy confined him to hospital in March 1958, when Congress House and its sculpture were finally unveiled. He lived for another year, working with undiminished resolve on a diverse array of portraits, stained-glass studies and the large bronze *Bowater House Group* commissioned by Sir Harold Samuel for the Edinburgh Gate entrance to Hyde Park (fig.61). 'I look upon myself as a worker', he had told

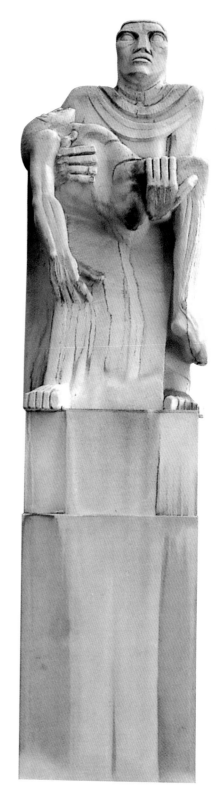

60 *Trades Union Congress War Memorial* 1956–7 Roman stone 300 × 150 × 120 (118 × 59 × 47) Congress House, Great Russell Street, London

61 *The Bowater House Group* 1958–9 Bronze Edinburgh Gate, Knightsbridge, London

the General Secretary of the TUC when first approached about the war memorial, 'and a long life of hard labour in my art is well known.'[27] He fulfilled that promise to the end, working on the *Bowater House Group* on the very day of his death in August 1959. Hence, perhaps, the almost reckless sense of energy surging through a sculpture that Epstein may have guessed would be his last. Just as Pan spurs on a father, mother, child and dog in their leaping eagerness to reach the park, so Epstein must have forced himself to push the Bowater House Group to a strangely frenzied completion. But his health had been deteriorating for some time, and none of the other bronzes produced during this final hectic year is among his memorable achievements. They lack the certitude of Epstein's finest work in stone, animated by an ambition that always honours the principle of 'carving direct' and the primal impulse he had discovered, as an exhilarated young man, while cutting ice on the frozen, mountain-fringed expanses of Greenwood Lake.

Notes

Introduction

1 The exhibition, selected by Daniel Abadie, was entitled *Un siècle de sculpture anglaise.*

2 Jacob Epstein, *Let there Be Sculpture: The Autobiography of Jacob Epstein*, 1940, pp.26–7. The teacher was Jean Paul Laurens.

3 See in particular Elizabeth Barker, 'The Primitive Within: The Question of Race in Epstein's Career 1917–1929', *Jacob Epstein Sculpture and Drawings*, ed. Terry Friedman and Evelyn Silber, Leeds and London 1987.

4 Henry Moore, 'Jacob Epstein', *The Sunday Times*, 23 Aug. 1959, reprinted in *Henry Moore on Sculpture*, ed. Philip James, 1966.

5 See Terry Friedman, 'Epsteinism', in Friedman and Silber 1987, pp.35–43.

6 See note 4.

7 Evelyn Silber, *The Sculpture of Epstein, with a Complete Catalogue*, Oxford 1986, p.43.

8 Epstein 1940, p.177.

9 See in particular Richard Cork, 'Image from Stone: Epstein as Carver', in Friedman and Silber 1987, pp.20–34.

Chapter One: 'A Sculptor in Revolt'

1 Epstein 1940, p.1.

2 Ibid., p.11.

3 As late as 1951 Epstein was still claiming Whitman as a key inspiration for his latest bronze group, *Social Consciousness* in Philadelphia.

4 Epstein 1940, p.10.

5 Ibid., p.13.

6 Ibid., p.220.

7 Ibid., p.18.

8 The sun-worshipper pictures, illustrated in *The World*, 27 Oct. 1912, are reproduced in Elizabeth Barker, 'New Light on Epstein's Early Career', *Burlington Magazine*, Dec. 1988, p.907.

9 Epstein to Edward W. Ordway, Feb. or March 1905, quoted by Barker 1988, p.906.

10 Epstein to Edward W. Ordway, March 1904, ibid.

11 Epstein to Edward W. Ordway, 4 Feb. 1905, ibid.

12 George Bernard Shaw to Robert Ross, 13 March 1905, *Robert Ross: Friend of Friends*, ed. M. Ross, 1952, pp.111–12.

13 Charles Holden, memoir dated 3 Dec. 1940, unpublished, preserved in the archives of Adams, Holden & Pearson, London.

14 Charles Holden, 'Thoughts for the Strong', *Architectural Review*, July 1905.

15 Charles Holden, speech delivered at opening of Epstein exhibition in Bolton, unpublished, courtesy of Adams, Holden & Pearson, London.

16 See note 14.

17 Epstein 1940, p.34.

18 Jacob Epstein, 'The Artist's Description of his Work', *British Medical Journal*, 4 July 1908.

19 The Lüksch figures, displayed at the Miethke Gallery, Vienna, were illustrated in *The Studio*, vol.37, 1906.

20 For a detailed analysis of Epstein's debts to sculptural precedent in the Strand scheme, see Richard Cork, *Art Beyond the Gallery in Early 20th Century England*, New Haven and London 1985, chap.1.

21 *Evening Standard*, 19 June 1908. A photograph of the front page is reproduced in *Un siècle de sculpture anglaise*, Galerie Nationale du Jeu de Paume, Paris 1996, p.48.

22 *British Medical Journal*, 11 July 1908.

23 *Evening Standard*, 23 June 1908.

24 *British Medical Journal*, 4 July 1908.

25 Eric Gill to William Rothenstein, 25 Sept. 1910, *Letters of Eric Gill*, ed. Walter Shewring, 1947, p.32.

26 The firm was John Daymond, of Westminster Bridge Road.

27 C. Lewis Hind, *The Post Impressionists*, 1911, p.67.

28 Epstein 1940, p.43.

29 See note 27.

30 Eric Gill Diaries, 9 Dec. 1913, Clark Library, Los Angeles.

31 Eric Gill to William Rothenstein, 25 Sept. 1910, *Letters of Eric Gill*, op. cit., pp.32–3.

32 Eric Gill to William Rothenstein, ibid., p.36.

33 At the Allied Artists' Salon, Albert Hall, summer 1912.

34 *Sun God* is in storage at the Metropolitan Museum of Art, which has no plans to display it.

35 Epstein 1940, p.51.

36 Henri Gaudier to Dr Uhlemayr, 18 June 1912; see Roger Cole, *Burning to Speak: The Life and Art of Henri Gaudier-Brzeska*, Oxford 1978, p.21.

37 Epstein 1940, p.44.

38 Ibid., p.45.

39 *Evening Standard*, 3 June 1912.

40 The inscription was only carved on the *Tomb* in autumn 1912, by Joseph Cribb after Gill's design.

41 *Pall Mall Gazette*, 6 June 1912.

42 Epstein to John Quinn, March 1912; see B.L. Reid, *The Man from New York: John Quinn and his Friends*, Oxford 1968, p.130.

43 Epstein to John Quinn, 17 March 1913; ibid.

44 Epstein to Francis Dodd, c. Sept. 1912, quoted by Evelyn Silber, 'The Tomb of Oscar Wilde', *Jacob Epstein: Sculpture and Drawings*, Leeds and London 1987, p.127.

45 Brancusi's Montparnasse carving is entitled *Monument to Tania Rachevskaia (The Kiss)*, 1909–10.

46 Epstein 1940, p.47.

47 For a full account of the Cave of the Golden Calf, see Cork 1985, chap.2.

48 Epstein 1940, p.116.

49 *Observer*, 16 June 1912.

Chapter Two: Dynamism and Destruction

1 Epstein 1940, p.64.

2 Ibid., p.63.

3 Ibid., p.64.

4 The drawing was illustrated in *BLAST*, no.1, 1914, pl.xvi.

5 Quoted by T.E. Hulme, *The New Age*, 25 Dec. 1913.

6 Ibid.

7 According to his correspondence with John Quinn, Epstein began buying African sculpture at least as early as February 1913.

8 The Brummer head, named after the dealer Joseph Brummer who once owned it, entered Epstein's collection in the 1930s.

9 Bernard van Dieren, *The New Age*, 7 March 1917.

10 Epstein to Bernard van Dieren, 8 March 1917; see Silber 1986, p.34.

11 The exhibition, *Twentieth Century Art: A Review of Modern Movements*, was held at the Whitechapel Art Gallery in the summer of 1914.

12 *The Egoist*, 16 March 1914.

13 Ezra Pound to John Quinn, 10 March 1916; *The Letters of Ezra Pound, 1907–1941*, ed. D.D. Paige, 1951, p.122.

14 *The New Age*, 21 Jan. 1915.

15 Ezra Pound to Isabel Pound, Nov. 1913, *The Letters of Ezra Pound*, op. cit., p.63.

16 *The Egoist*, 16 March 1914.

17 According to family legend, Epstein ordered the granite *Mother and Child* to be dumped in the Hudson river.

18 Listed in the catalogue of Epstein's one-man show at the Leicester Galleries, London, 1917.

19 T.E. Hulme, 'Modern Art and its Philosophy', in *Speculations*, ed. Herbert Read, 1924, p.104.

20 Epstein, foreword to Read 1924.

21 For an extended discussion of the rock drill as a mechanised invention, see Richard Cork, *Vorticism and Abstract Art in the First Machine Age*, 1976, vol.2, pp.470–2.

22 Epstein 1940, p.70.

23 Ibid.

24 Ibid.

25 *Manchester Guardian*, 15 March 1915.

26 *Observer*, 14 March 1915.

27 Augustus John to John Quinn, 3 April 1915; see Reid 1968, p.203.

28 *BLAST*, no.2, 1915, p.78.

29 Ezra Pound, 'Vortex. Pound', *BLAST*, no.1, 1914, p.153.

30 See Richard Cork, *A Bitter Truth: Avant-Garde Art and the Great War*, New Haven and London 1994.

31 Lady Epstein, in an interview with the author, recalled 'Epstein saying that he abandoned the drill because he hadn't made it himself, it was just a machine'.

32 Epstein to John Quinn, 11 Feb. ?1917; see Reid 1968, p.299.

33 Sir Martin Conway to Robertson, 13 Dec. 1917, Imperial War Museum, London, Epstein file.

34 Epstein to Bernard van Dieren, [n.d.]; see Silber 1986, p.36.

35 Epstein to John Quinn, [n.d.]; see Reid 1968, p.374.

36 Epstein 1940, p.122.

Chapter Three: Between The Wars

1 Epstein to John Quinn, 11 Feb. ?1917; see Reid 1968, p.299.

2 *The Graphic*, 14 Feb. 1920.

3 Minute Book of the Hudson Memorial Committee, 26 June 1923; see Silber 1986, p.155.

4 Epstein 1940, p.128.

5 See Terry Friedman, 'The Hyde Park Atrocity'. Epstein's *Rima: Creation and Controversy*, Leeds 1988, for a detailed account of the affair.

6 *Daily Mail*, 20 May 1925.

7 Epstein 1940, p.74.

8 *Manchester Guardian*, 3 Aug. 1929.

9 Quoted by Christian Barman, *The Man who Built London Transport: A Biography of Frank Pick*, 1979, p.129.

10 *Evening Standard*, 1 July 1929.

11 See Cork 1985, pp.293–4.

12 *Daily Express*, 7 Feb. 1931.

13 Epstein 1940, p.217.

14 Epstein's purchases from Moore included the concrete *Suckling Child*, bought from Moore's first one-man show at the Warren Gallery in 1928.

15 Henry Moore, 'Jacob Epstein', op. cit.

16 Henry Moore, interview with the author, 26 May 1981.

17 Quoted by Epstein in Epstein 1940, p.289.

18 Ibid., p.177.

19 Ibid., p.176.

20 Paul Vaughan, *Doctors' Commons: A Short History of the British Medical Association*, 1959, p.174.

21 *Evening Standard*, 10 May 1935.

22 Charles Holden, memoir, 5 March 1958, Adams, Holden & Pearson archives, London.

23 Epstein 1940, p.41.

24 Henry Moore, interview with the author, 26 May 1981. Only after his death did the Academy stage a Moore retrospective, in 1988.

25 Epstein 1940, p.195.

26 Walt Whitman, *Complete Poetry & Selected Prose and Letters*, 1938, p.95.

27 Jacob Epstein, 'The Artist's Description of his Work', *British Medical Journal*, 4 July 1908

28 Epstein 1940, pp.171–2.

29 *Picture Post*, 24 June 1939.

30 Quoted by Stephen Gardiner, *Epstein: Artist against the Establishment*, 1992, p.373.

31 The Tate Gallery only acquired its first Epstein carving, *Female Figure in Flenite*, in 1972.

Chapter Four: The Final Years

1 Jacob Epstein to Mrs Robeson, 11 Sept. 1939; see Gardiner 1992 p.377.

2 For a full account of Epstein the collector, see Ezio Bassani and Malcolm McLeod, 'The Passionate Collector', in Friedman and Silber 1987, pp.12–19.

3 Epstein 1940, pp.155–6.

4 Ibid., p.195.

5 See Genesis 33: 22–32.

6 Jacques Lipchitz, *My Life in Sculpture*, New York 1972, p.120.

7 Epstein 1940, p.168.

8 *Evening Standard*, 8 June 1949.

9 Epstein 1940, p.178.

10 *The Listener*, 23 March 1950.

11 *Sunday Times*, 19 March 1950.

12 Epstein 1940, p.176.

13 Jacob Epstein to Warden Smith, 2 Sept. 1951, New College Archives, Oxford.

14 See Silber 1986, p.201.

15 Gerald Barry, speech at a Symposium on 'Painting, Sculpture and the Architect', organised by the ICA and the MARS Group at the RIBA, 2 Sept. 1949, published in *The Architect and Building News*, 16 Sept. 1949.

16 Huw Wheldon, quoted by Hugh Casson, 'Period Piece', *A Tonic to the Nation: The Festival of Britain 1951*, 1976, p.81.

17 *The Dial*, Jan. 1928, reprinted in Henry McBride, *The Flow of Art: Essays and Criticisms*, ed. Daniel Catton Rich, New Haven and London 1997, p.233.

18 Fairmount Park Association Archives, held by the Historical Society of Pennsylvania, see Silber 1986, p.212.

19 Louis Osman, 'Cavendish Square – Past and Present', *Journal of the London Society*, 20 Feb. 1957.

20 See Gardiner 1992, p.442.

21 See Roger Berthoud, *The Life of Henry Moore*, 1987, pp.245–6.

22 Basil Spence, *Phoenix at Coventry*, 1962, p.68.

23 Epstein 1940, p.105.

24 *Trades Union Congress Memorial Building Sculpture Competition: General Conditions and Instructions*, 1954, items 21–2, Congress House, London.

25 The marble deteriorated, and has since been replaced by a different material.

26 Epstein to his daughter, 1 March 1956; see Silber 1986, p.221.

27 Epstein to Sir Vincent Tewson, 11 Dec. 1954, TUC Archive, London.

Photographic Credits

Bibliography

Barker, E. 'New Light on Epstein's Early Career', *Burlington Magazine*, Dec. 1988.

Barman, C. *The Man who Built London Transport: A Biography of Frank Pick*, London 1979.

Berthoud, R. *The Life of Henry Moore*, London 1987.

Brown, O. *Exhibition: The Memoirs of Oliver Brown*, London 1968.

Buckle, R. *Jacob Epstein Sculptor*, London 1963.

Buckle, R., and Lady Epstein, *Epstein Drawings*, London 1962.

Coen, E. '"Ardour for Machinery" (ferveur pour les machines)', *Un Siècle de sculpture anglaise*, exh. cat., National Galerie du Jeu de Paume, Paris 1996.

Cole, R. *Burning to Speak: The Life and Art of Henri Gaudier-Brzeska*, Oxford 1978.

Collins, J. *Eric Gill: The Sculpture*, London 1998.

Compton, S. (ed.) *British Art in the 20th Century: The Modern Movement*, exh. cat., Royal Academy 1987.

Compton, S. (ed.) *Henry Moore*, exh. cat., Royal Academy, London 1988.

Cork, R. *Vorticism and Abstract Art in the First Machine Age*, 2 vols., London 1975 and 1976.

Cork, R. *Art Beyond the Gallery in Early Twentieth-Century England*, New Haven and London 1985.

Cork, R. *A Bitter Truth: Avant-Garde Art and the Great War*, New Haven and London 1994.

Cork, R. 'Jacob Epstein et la sculpture anglaise au debut du siècle', in *Un Siècle de sculpture anglaise*, exh. cat., Galerie Nationale du Jeu de Paume, Paris 1996.

Cork, R. 'Vorticism and Sculpture', *BLAST: Vortizismus – Die Erste Avantgarde in England 1914–1918*, ed. Karin Orchard, exh. cat., Sprengel Museum, Hanover, and Haus der Kunst, Munich 1996.

Curtis, P., and A.G. Wilkinson, *Barbara Hepworth: A Retrospective*, exh. cat., Tate Gallery Liverpool 1994.

Elsen, A.E. *Origins of Modern Sculpture: Pioneers and Premises*, London 1974.

Epstein, J. 'The Artist's Description of his Work', *British Medical Journal*, 4 July 1908.

Epstein, J. *Let There Be Sculpture: The Autobiography of Jacob Epstein*, London 1940.

Epstein, J., and A. Haskell. *The Sculptor Speaks: A Series of Conversations on Art*, London 1931.

Fagg, W. Introduction to *The Epstein Collection of Tribal and Exotic Sculpture*, exh. cat., Arts Council, London 1960.

Friedman, T., and Silber, E. (eds.) *Jacob Epstein Sculpture and Drawings*, Leeds and London 1987.

Friedman, T. 'The Hyde Park Atrocity': *Epstein's Rima: Creation and Controversy*, Leeds 1988.

Gardiner, S. *Epstein: Artist against the Establishment*, London 1992.

Gill, E. *Autobiography*, London 1940.

Hapgood, H. *The Spirit of the Ghetto*, New York 1902.

Harrison, C. *English Art and Modernism 1900–1939*, London and Indiana 1981.

Harrison, M. (ed.) *Carving Mountains: Modern Stone Sculpture in England 1907–37*, exh. cat., Kettle's Yard, Cambridge 1998.

Holden, C. 'Notes', *The Architectural Review*, June 1905.

Holden, C. 'Thoughts for the Strong', *The Architectural Review*, July 1905.

Hulme, T.E. 'Mr Epstein and the Critics', *The New Age*, 25 Dec. 1913.

Hulme, T.E. *Speculations: Essays on Humanism and the Philosophy of Art*, ed. H. Read, with frontispiece and foreword by Epstein, London 1924.

Humphreys, R. (ed.) *Pound's Artists: Ezra Pound and the Visual Arts in London, Paris and Italy*, London 1985.

James, P. (ed.) *Henry Moore on Sculpture*, London 1966.

Jones, A.R. *The Life and Opinions of Thomas Ernest Hulme*, London 1960.

Lewis, W. *Wyndham Lewis on Art*, ed. W. Michel and C.J. Fox, London 1969.

MacCarthy, F. *Eric Gill*, London 1989.

Nairne, S., and N. Serota (eds.) *British Sculpture in the Twentieth Century*, exh. cat., Whitechapel Art Gallery, London 1981.

Osman, L. 'Architect, Sculptor and Client, with Special Reference to Epstein's Madonna and Child', *Architectural Association Journal*, 70, 1954.

Pennington, M. *An Angel for a Martyr: Jacob Epstein's Tomb for Oscar Wilde*, London 1987.

Pound, E. 'Affirmations. III. Jacob Epstein', *The New Age*, 21 Jan. 1915.

Pound, E. *Gaudier-Brzeska: A Memoir* London 1916.

Reid, B.L. *The Man from New York: John Quinn and his Friends*, Oxford 1968.

Silber, E. *Rebel Angel: Sculpture and Watercolours by Sir Jacob Epstein (1880–1959)*, exh. cat., Birmingham Museum and Art Gallery 1980.

Silber, E. *The Sculpture of Epstein with a Complete Catalogue*, Oxford 1986.

Silber, E., and D. Finn. *Gaudier-Brzeska*, London 1996.

Spence, B. *Phoenix at Coventry*, London 1962.

Wilson, S. '"Rom": An Early Carving by Jacob Epstein', *Burlington Magazine*, vol. 119, 1977.

Zilczer, J. 'The Noble Buyer': *John Quinn, Patron of the Avant-Garde*, exh. cat., Hirshhorn Museum of Art, Washington 1978.

Index